IMAGES
of America

DUNWOODY

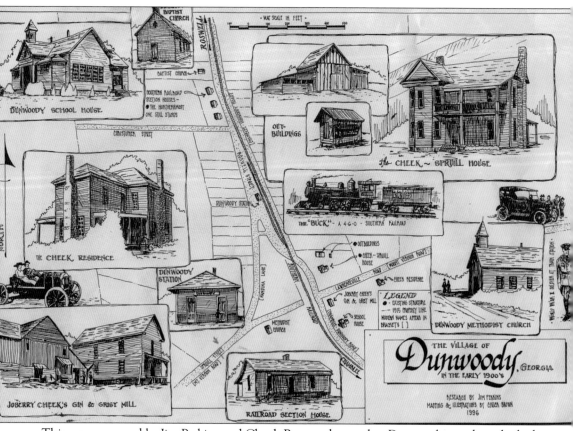

This map, prepared by Jim Perkins and Chuck Brown, shows what Dunwoody may have looked like in the early 1900s. It includes several of the homes and buildings that were centered around the intersection of Mount Vernon Road and Chamblee Dunwoody Road. The only buildings on this map that still stand today are the Cheek Spruill House and outbuilding and one railroad section house. (Courtesy of Jim Perkins and Chuck Brown).

ON THE COVER: The Dutch House was built by Glenn Austin for the children of Dunwoody School to enjoy and also to help them learn about other parts of the world. His wife was teacher Nettie Southern Austin, pictured here with some of her students. This photograph was taken in the 1940s. (Courtesy of the Austin family.)

IMAGES
of America
DUNWOODY

Valerie Mathis Biggerstaff

ARCADIA
PUBLISHING

Published by Arcadia Publishing
Charleston SC, Chicago IL, Portsmouth NH, San Francisco CA

Printed in the United States of America

Library of Congress Control Number: 2009940680

For all general information contact Arcadia Publishing at:
Telephone 843-853-2070
Fax 843-853-0044
E-mail sales@arcadiapublishing.com
For customer service and orders:
Toll-Free 1-888-313-2665

Visit us on the Internet at www.arcadiapublishing.com

To my family, for their encouragement and support

CONTENTS

FOREWORD

Through careful research with descendants of early Dunwoodians, Valerie Biggerstaff has made Dunwoody history come alive! Many of the pictures included in this important pictorial book have never before been seen in any Dunwoody publication. The residents of today's Dunwoody and those of the future owe Valerie a debt of gratitude for this detailed history.

The Dunwoody Preservation Trust, Inc., is especially grateful for this factual and enlightening book.

—Lynne Byrd
The Dunwoody Preservation Trust, Inc.

We drink from wells we did not dig.
We build on foundations we did not lay.
Preserve what you can while you plan for the future.

—*The Writings of Jim Perkins, Dunwoody Historian*
Compiled by Bill Drury

ACKNOWLEDGMENTS

I want to thank Ken Anderson and Suzanne Austin Carley for spending hours letting me look through their pictures and sharing their family histories with me. Thanks to Carlton Renfroe, Jeff Porter, and Bill Ware, as well as Sue Cunnold for sharing the photographs and stories of the Dunwoody United Methodist Church history room. I am also grateful to Michael Hitt, Roswell historian, who was my resource for all things related to the Roswell Railroad.

A special thanks to Lynne Byrd of the Dunwoody Preservation Trust, not only for sharing her photograph collection but also for all she does to preserve history in Dunwoody. Thank you also to Jim Perkins and Cathy Cobbs for allowing me to follow in Jim's footsteps as the writer of "Past Tense" for the *Dunwoody Crier* newspaper.

Finally, thank you to my family for supporting me while I took on this project.

INTRODUCTION

Today's Dunwoody stands along the route of the old Hightower Trail, which the Cherokees used to traverse Georgia, including Dunwoody. The trail has been identified and mapped out in recent years. People pass over and live around the trail without knowing it existed.

Situated on the outskirts of Atlanta between Roswell, Sandy Springs, and Chamblee, Dunwoody had its beginnings as a simple farming community. Plots of 202.5 acres were distributed by lottery when the Cherokees ceded their land in 1821. In July 1864, Civil War battles took place in nearby Roswell, followed by a march of Union soldiers through Dunwoody. The families prepared by hiding valuables on their property. The soldiers stopped at the Copeland plantation for water from their well and took bags of food. The lady of the house begged them to leave one bag to feed her children, and they did. Dunwoody consisted of a few scattered farmhouses at the time.

Confederate major Charles Dunwody came home to Roswell following the Civil War. He bought some land and began to farm in a new area, which needed a post office. His application for a post office was what gave Dunwoody its name. The only problem was that the U.S. Postal Service added an "o" to the name. Today not only is the community named Dunwoody, but many roads that go well beyond Dunwoody continue to use this name.

The year 1881 brought change to Dunwoody by way of the Roswell Railroad. The engine, named "Old Buck" or "Dinky," traveled from Chamblee to Roswell twice a day for 40 years. The little train didn't turn around, it traveled forwards to Roswell and backwards back to Chamblee. There were four stops along the way for the train. Starting from Roswell, the first stop for the train was Powers Station, in the area where Pitts Road and Spalding Drive meet. Morgan Falls Junction was near the intersection of Roberts Drive and Spalding Drive. The Bull Sluice line of the railroad went from there to Morgan Falls at the Chattahoochee River. Dunwoody Depot was in the heart of Dunwoody on Chamblee Dunwoody Road, just north of Mount Vernon Road. Moving south toward Chamblee was Wilson's Mill, a flag stop for the train.

The Roswell Railroad made it easier for Dunwoody farmers to send produce to Atlanta. Businesses started sprouting up around the depot. P. L. Moss built a store in the triangle at Nandina Lane. He also dug a well for the community and for travelers. Cephas Spruill had a blacksmith shop, and W. R. Nash and Will Cheek had a feed and grocery store on the west side of Nandina Lane. In addition, on the west side was Dr. Pucket's livery stable, feed and fertilizer store, pharmacy, and home. There were three railroad section houses, followed by Dunwoody Baptist Church. The Methodist church was on Mount Vernon Road, then called Lawrenceville Road. Across Chamblee Dunwoody Road were Joberry Cheek's cotton gin and corn and flour mill. Larkin Copeland's general merchandise store was north of there, followed by his home. Just north on Chamblee Dunwoody Road was New Hope Presbyterian Church and Cemetery.

With the start of World War I, many young men from Dunwoody enlisted or were drafted. Dunwoody men worked on the construction of nearby Camp Gordon, and soldiers were entertained in Dunwoody homes.

The people of Dunwoody rallied during World War II, doing their part any way they could. Men went off to fight, and the people back home collected scrap metal and rubber and collected stamps for war bonds. The postwar years marked big changes for Dunwoody, as more homes began to spring up, followed by entire subdivisions.

In 1970, Interstate 285 was completed; it encircled Atlanta and provided easy access to Dunwoody. More shopping centers were built, as well as banks and office buildings. In 1971, the Perimeter Mall shopping center opened on land that had belonged to the pioneer Spruill family.

The Dunwoody School was the heart of the community. The first one-room wooden schoolhouse was built in the late 1800s. A new larger and painted wooden school followed it in the 1920s, followed in turn by a brick school in the 1930s. Those who attended the old school warmly remember the teachers and principals of Dunwoody School. The Dutch House, pictured on the cover of this book, is one of the special memories of students of the old grammar school.

For many years, Dunwoody didn't have its own high school. Students attended nearby Chamblee High School. Now Dunwoody has several elementary schools, a middle school, a high school, and even a few private schools. There are many churches and synagogues in Dunwoody also, many of which opened their doors in the 1970s.

Dunwoody has changed immensely over the years. It was a farming town, with a main street, a few businesses, and farmhouses scattered about. Now it is filled with homes of every size, businesses of every type, and all the shopping choices one could ever need. It is a bustling community full of traffic and the usual headaches and has recently become a city with its own mayor and police department. Even still, it remains the kind of place where neighbors help each other out, and residents might just run into someone they know at the grocery store.

One

CHEROKEE TRAILS AND

EARLY SETTLERS

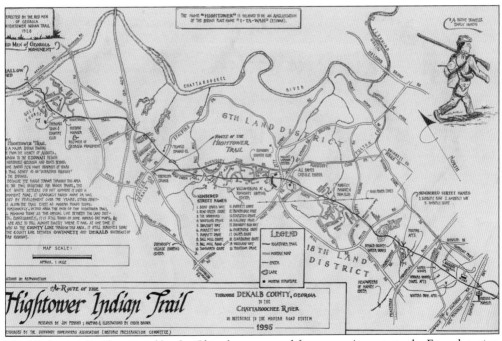

The Hightower Trail was used by the Cherokees to travel from near Augusta to the Etowah region of northwest Georgia. A path through Dunwoody led to the shallow part of the Chattahoochee River near Roswell. The Hightower Trail still designates the border between parts of Gwinnett and DeKalb Counties on maps today. Jim Perkins researched the map seen here, and Chuck Brown did the illustrations. It is on file with the DeKalb, Roswell, and Atlanta Historical Societies. (Courtesy of Jim Perkins and Chuck Brown.)

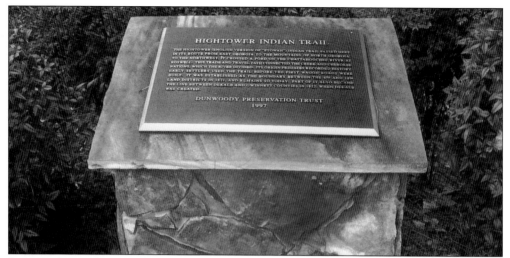

In 1997, this marker was placed on the grounds of All Saints Catholic Church in Dunwoody to identify a section of the Hightower Trail. The Hightower Trail was one of the major trails used by Native Americans before the land was ceded in the Treaty of 1821. The path was too rough for wagon travel, so it never became a permanent road. (Photograph by Valerie Biggerstaff.)

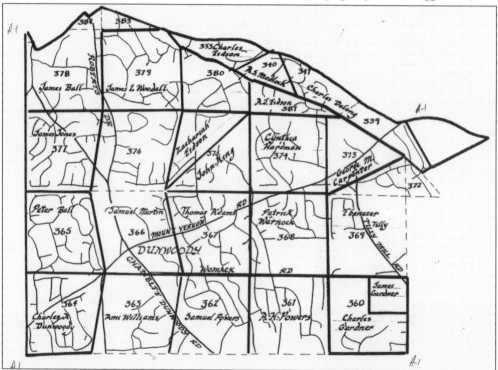

This 1830s DeKalb County land lot map shows the names of original landowners following the ceding of Cherokee land. Along the northernmost border of the map is the Chattahoochee River. Several of the names seen here are still used in Dunwoody today, such as Tilly Mill Road and Ball Mill Road. Carpenter family members still owned their original land up until the 1990s. The Warnock family still owns a small piece of land and their family home place. The community namesake, Charles Dunwody, appears on the bottom left of the map. (Courtesy of Jim Perkins.)

10

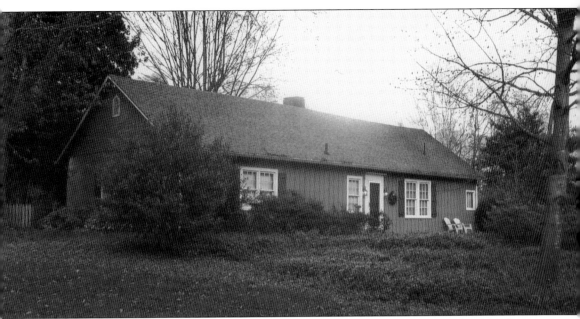

This is how the Larkin Martin home looks today, so it is difficult to tell that it is the oldest home still standing in Dunwoody. It was originally built in 1840 but has gone through many changes over the years. The home was built with the front porch facing present-day Roberts Drive. Larkin Martin was a founding member of nearby Ebenezer Primitive Baptist Church. One of the later owners of the home, Richard Titus, wrote a book, *Dunwoody Isn't Bucolic Anymore*, in which he describes the renovations he made to the home and what life was like for him and his family in Dunwoody. (Photograph by Valerie Biggerstaff.)

Back even before the Civil War, travelers stopped at Obediah's Plantation for a drink from Obediah Copeland's well. Lee Eula Copeland, the last family member to live there, remembered stories told by her grandmother Salina Copeland. She told of how Creek and Cherokee Indians, settlers, and prospectors would stop. Sometimes there would be a line of wagons down the road. (Photograph by Suzanne Austin Carley.)

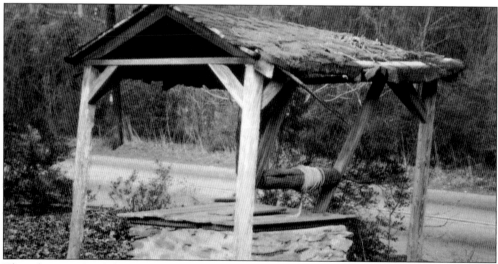

This photograph of the well on Obediah's Plantation was taken a few years before it was torn down to make way for a Fulton County public school. When it was torn down, the stones from the base were saved and later reused to build a replica well on the grounds of the new Dunwoody Springs Elementary School. (Courtesy of the Dunwoody Preservation Trust.)

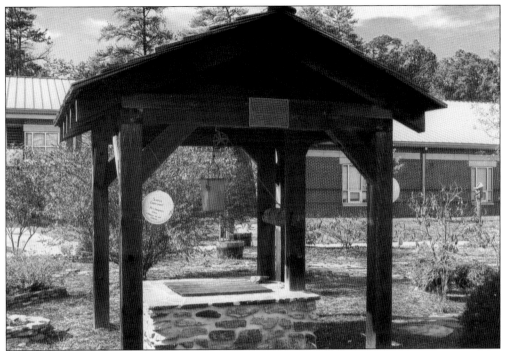

Dunwoody Springs Elementary School's replica of the Copeland Well, located in a courtyard behind the school, was built from stones from the original well. The school also has a scaled Roswell Railroad engine in its library on which children can sit and read their books. (Photograph by Valerie Biggerstaff.)

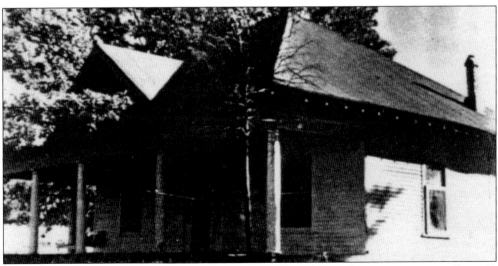

Maj. Charles Dunwody built this home after returning from the Civil War. He grew up in Roswell, Georgia, in a home that still stands. His Dunwoody home is gone, but a monument stands in his honor at Ebenezer Primitive Baptist Church. The name Dunwody inexplicably gained an extra "o" when Major Dunwody applied for a post office in the community. (Courtesy of Dunwoody United Methodist Church.)

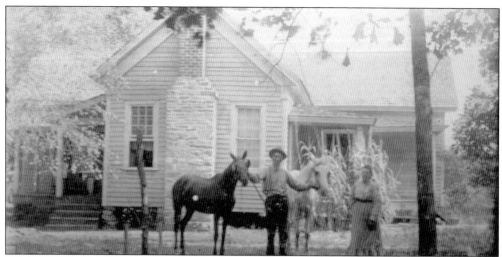

While John W. Southern courted his future wife, Sally (Sarah E.), he was gone for long periods of time guiding groups who wanted to move out west. They married and settled in Cherokee County, but in 1882, John picked out a 40-acre site on Mount Vernon Road in Dunwoody. John, Sally, and their daughter moved there. One half of the acreage remained beautiful wooded property, but there was a vegetable garden behind the home. They also had orchards of apples, peaches, pears, figs, and cherries as well as raspberries, strawberries, and grape vines. (Courtesy of the Austin family.)

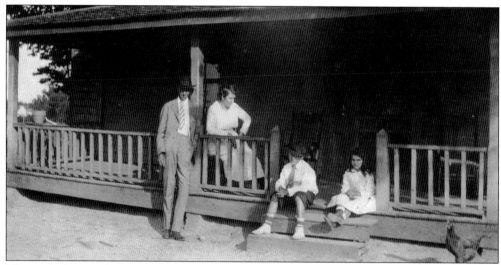

This is the home of Nettie and Glenn Austin on Mount Vernon Road across from the present-day Dunwoody United Methodist Chapel. They moved here to be near Nettie's mother, Sally Southern, after John Southern died. Nettie Mae Austin, the fourth child of Glenn and Nettie, remembers hearing her brother John's crystal radio set for the first time at this home. Pictured in this photograph are Glenn Austin, Nettie Austin, son John, daughter Gladys, and of course one of the family roosters. As the Austin family grew, they built a larger home nearby. (Courtesy of the Austin family.)

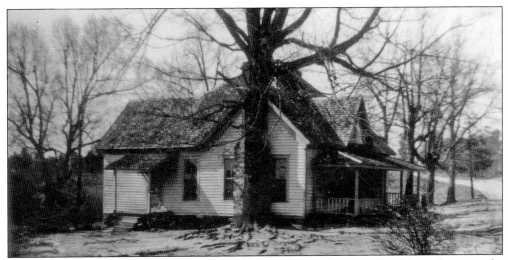

This is a view of Nettie and Glenn Austin's home on Mount Vernon Road from the east side. The Dunwoody Methodist Churh was on the same side of the road, across from where it sits today. The portion of Mount Vernon Road that is seen in the photograph leads to Sandy Springs. (Courtesy of the Austin family.)

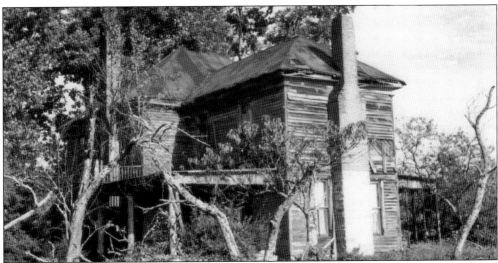

This home was built in 1886 by Joberry Cheek and stood on the southeast corner of the Mount Vernon Road and Chamblee Dunwoody Road intersection. Joberry Cheek cut pine trees and used his own sawmill in the building of his home. Lizzie Cheek Newhard lived in the home close to the time this picture was taken in 1969. She was known to say "I like my old-timey things. They're what I'm used to. I don't want to move anywhere else." (Courtesy of the Dunwoody Preservation Trust.)

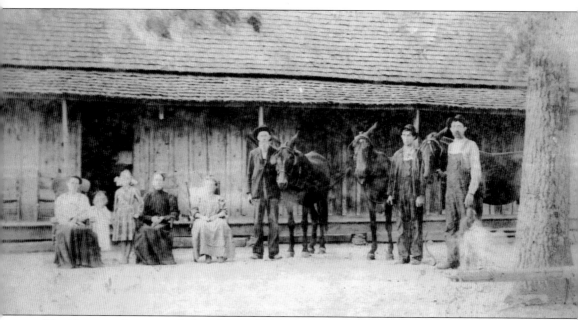

The Carpenter home stood where Mount Vernon Road and Tilly Mill Road meet. This land was in their family since the time of the land lottery. This photograph shows several family members; from left to right are Effie Spruill Carpenter, Kathryne Carpenter, Lucy Carpenter Anderson, Amanda Carpenter, Matilda Donaldson Carpenter, Francis (Owen) Carpenter, Cicero Carpenter, and Ambrey Carpenter. (Courtesy of the Anderson family.)

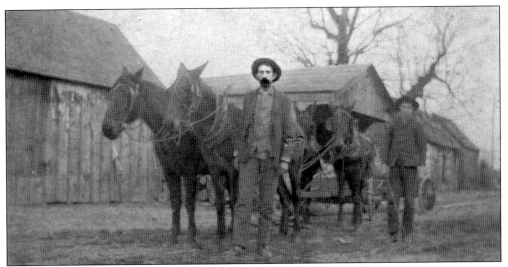

Brothers Ambrey (left) and Cicero Carpenter are shown in this photograph working with some mules. (Courtesy of the Anderson family.)

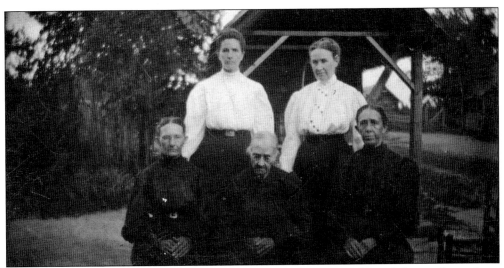

Some of the women of the Carpenter family posed for this picture. From left to right are Lucy Carpenter Hays, Laura Carpenter Hays, Susan Carpenter, Kansas Carpenter Ball, and Amanda Carpenter. (Courtesy of the Anderson family.)

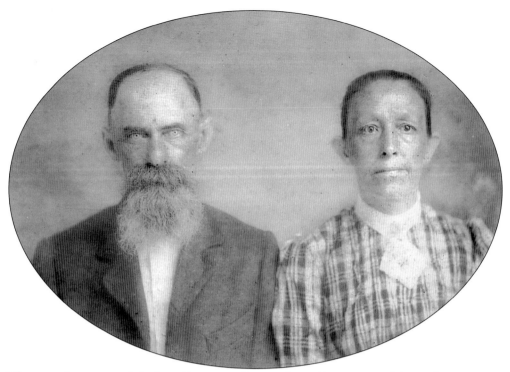

These are the parents of Ambrey Carpenter: Francis Owen Carpenter and Amanda Carpenter. Amanda Carpenter was born in 1859, and this photograph was taken around 1905. (Courtesy of the Anderson family.)

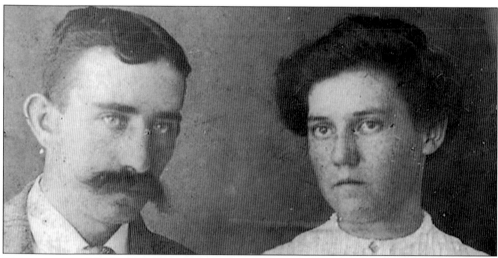

This portrait is of Ambrey M. Carpenter (born in 1880) and Effie Spruill Carpenter (born in 1888), who met at the Dunwoody School. They were married in April 1904. Ambrey was a carpenter who worked on Camp Gordon, the Biltmore Hotel, and Davisons department store in downtown Atlanta. (Courtesy of the Anderson family.)

The Swancey farmhouse was purchased by Willis J. Swancey and his wife, Clara, in 1929. The original home was built in 1889 and had only three rooms. Willis Swancey added a room and a porch initially and later added an upstairs room. The home stayed in the Swancey family until it was sold in 1996. Several modifications have occurred since then, but the farmhouse charm has been maintained. (Photograph by Valerie Biggerstaff.)

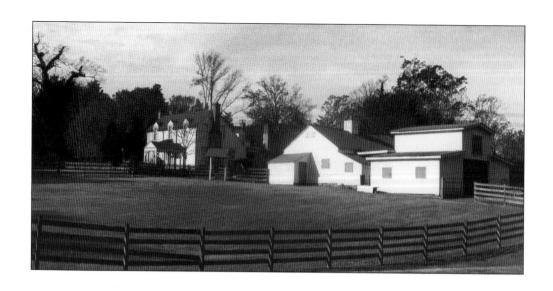

W. J. Donaldson built this two-story home in 1870 at the corner of Chamblee Dunwoody Road and Vermack Road. His wife, Milly Adams Donaldson, managed the farm for 31 years following his death in 1900. The family cemetery is also located on the property. Several outbuildings still exist, including a blacksmith shop, three-stall barn, well, washhouse, and commissary. When Lois Bannister purchased the home as a summer home, she made several additions. Linda and David Chestnut became owners in the 1970s and restored the home. This home was recently added to the National Register of Historic Places. (Photograph above by Noah Byrd; photograph below by Valerie Biggerstaff.)

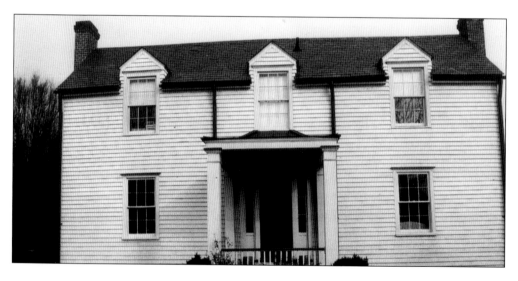

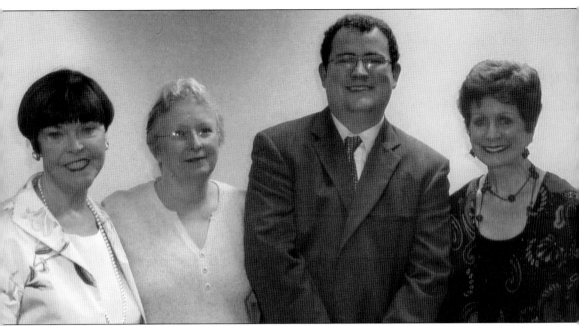

Lynne Byrd and Joyce Amacher presented the request for the Donaldson Bannister home to be listed on the National Register of Historic Places. Pictured from left to right are Joyce Amacher, Vivian Price Saffold (DeKalb County historian), Keith Hèbert (from the preservation office), and Lynne Byrd. (Photograph by Noah Byrd.)

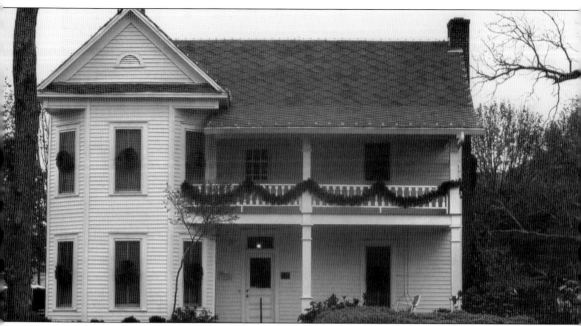

In 1906, Joberry Cheek built the Cheek Spruill Home, commonly known in town as "The Dunwoody Farmhouse," for his son, Bunyan Cheek. It sits at the corner of Mount Vernon Road and Chamblee Dunwoody Road. The original home was one story, and when the second story was added, the original first level was lifted up and an addition was built beneath it. The home was placed on the National Register for Historic Places thanks to Lynne Byrd of the Dunwoody Preservation Trust. This home is used for community events, such as the annual "Light Up Dunwoody" celebration held in late November. (Photograph by Valerie Biggerstaff.)

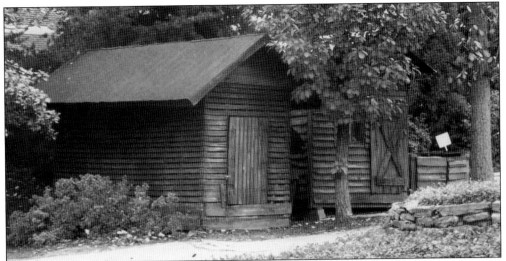

The smokehouse and chicken house of the Cheek Spruill home were saved and moved by the Dunwoody Preservation Trust. The barn on the property could not be saved. This corner of Dunwoody, at the intersection of Mount Vernon Road and Chamblee Dunwoody Road, reminds many who pass by each day of how Dunwoody looked long ago. (Photograph by Valerie Biggerstaff.)

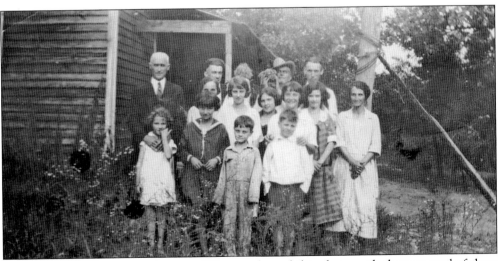

Ware family members were pioneers of Dunwoody, and this photograph shows several of them along with other Dunwoody residents. Pictured from left to right are (first row) Amanda Ware, W. N. Ware, and Bill Nash; (second row) Lee Nash, Ethel Nash, Jeannie Nash Raney, Lelia Ware, Harper Nash, and Ella Ware; (third row) John Nash (Lelia's husband), Carl Raney, ? Raney, Don Raney, W. J. Ware, and Winifred Reeves. (Courtesy of Bill Ware.)

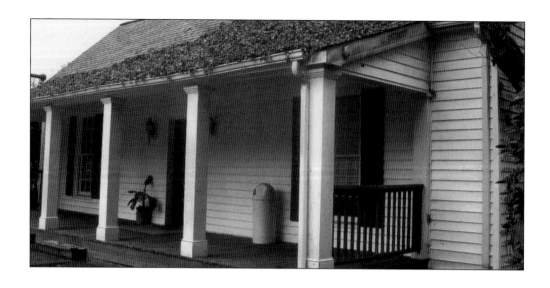

The 1876 W. N. Ware home is located next to the Life Center Family Church on Dunwoody Club Drive. William Ware Sr. married Ella Warnock, the daughter of another pioneer Dunwoody family. The land owned by the Wares once stretched from where Dunwoody Club Drive is today to the Chattahoochee River, including where Orchard Park Shopping Center stands today. The Wares left Dunwoody during the Great Depression, but descendant Bill Ware returned. The Ware home is used as an office by Life Center Family Church. (Both photographs by Valerie Biggerstaff.)

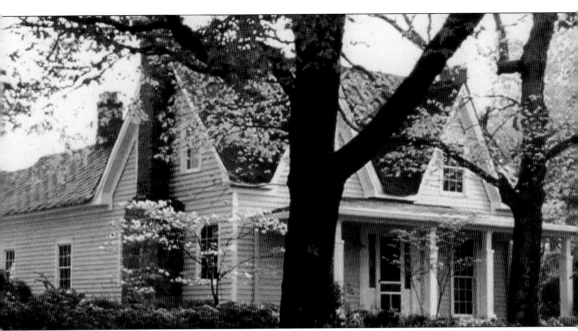

The Charles Woodall home is located on Nesbit Ferry Road in Fulton County near the Chattahoochee River. Charles Woodall once operated a ferry on the Chattahoochee. This home has been beautifully restored, and the property includes a log cabin, barn, and other outbuildings. (Photograph by Valerie Biggerstaff.)

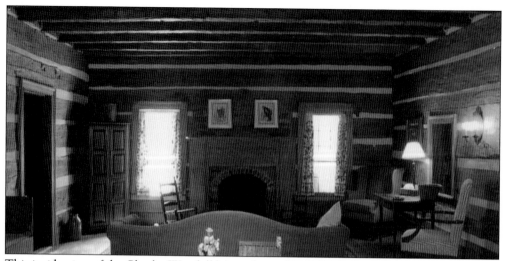

This inside view of the Charles Woodall home shows the walls of a log cabin that was added on to the home. (Photograph by Valerie Biggerstaff.)

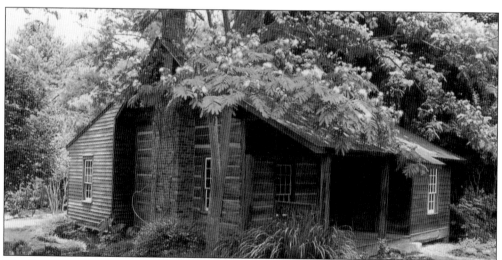

The Bregenzer family, who have restored the home and cared for all the historic outbuildings, relocated this log cabin to the property of the historic Charles Woodall home. (Photograph by Valerie Biggerstaff.)

On May 24, 1875, Peter Ball deeded over 202.5 acres of land, lot no. 365, to his daughter Elizabeth Spruell. The names Spruell and Spruill are frequently seen in Dunwoody and Sandy Springs history using both spellings. (Courtesy of Jim Perkins.)

```
__ may 24th, 1872.
                                      Hiram J. Williams - Clerk S. C.

STATE OF GEORGIA:

DEKALB COUNTY:

        This Indenture made the first day of March in the year of our Lord eighteen
hundred and sixty-seven between Peter Ball of said State and County of the one part and
Elizabeth Spruell, daughter of the said Peter Ball of the State aforesaid and County of
DeKalb of the other part, Witnesseth, that the said Ball for and in consideration of
the natural love and effection which he has and bears to his said daughter Elizabeth
Spruell wife of Wm. Spruel hath given, granted and conveyed and does by these presents
give, grant, and convey unto the said Elizabeth and her bodily heirs and assigns all of
that tract or parcel of land situate, lying and being in the eighteenth district of De-
Kalb County, agreeably to original survey known by the number three hundred and sixty-
five (365) containing two hundred two and one half acres (202-1/2) ..
        To have and to hold said parcel of land unto her the said Spruell and her
bodily heirs and assigns together with all and singular the rights, members and appur-
tenances to the same in any manner belonging to her and their own proper use, benefit and
behoof in fee simple.
        In Testimony whereof the said Peter Ball hath hereunto set his hand and af-
fixed his seal the day and year above written.
Signed, sealed and delivered in presence of:
William M. Ball                         Peter Ball              L. S.
William Power - J. P.
                Recorded May 25th, 1872.
                                      H. J. Williams - Clerk S. C.
```

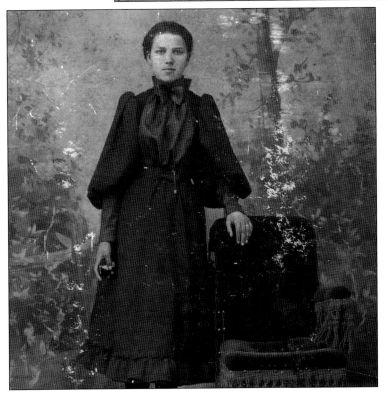

This portrait of Nettie Southern at age 16 was done in 1896. She left Dunwoody to attend Georgia State Normal School in Athens. Southern taught first in Roswell and then for many years at the Dunwoody School, earning $35 per month when she started out. She was so well known and loved that DeKalb County later named a new Dunwoody elementary school for her. Austin Elementary School was dedicated in 1975. (Courtesy of the Austin family.)

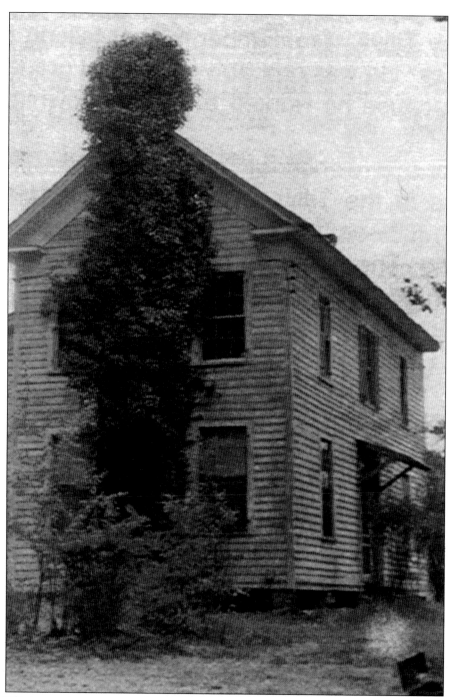

The Tilly home place once stood near the intersection of Tilly Mill Road and North Peachtree Road on the northeast corner. This photograph was taken about 1973. John William Fletcher "Will" Tilly owned this home as well as a cotton gin, sawmill, and gristmill. He and his wife, Louisa Adaline Lively, had four children. The youngest inherited the land and mills and stayed on after their death. The Tilly School was located about a half-mile down the road, where Tilly Mill and Peeler Roads meet. (Courtesy of the Tilly family.)

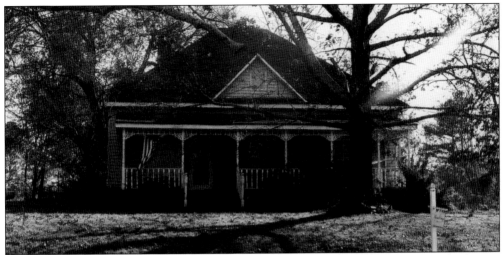

William Robert Warnock fought in the Civil War and was injured at Gettysburg. He and his wife, Martha Adams Warnock, were founding members of the Ebenezer Primitive Baptist Church. Their granddaughter, Florence Warnock, married Carey Spruill, and they were the last inhabitants of the Cheek Spruill Farmhouse (known as the Dunwoody Farmhouse). Other grandchildren include W. N. Ware, Lelia Ware, and Lon Eidson. This photograph shows how the Warnock home looks today. (Photograph by Valerie Biggerstaff.)

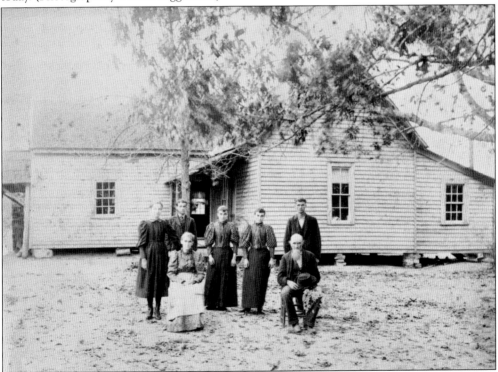

This 1800s photograph of the Warnock home on Mount Vernon Road features Martha Adams Warnock (seated left) and William R. Warnock (seated right) with, from left to right, Georgia Warnock, Dow Warnock, Ella Warnock, Lela Warnock, and Chris Warnock. (Courtesy of the Ware family.)

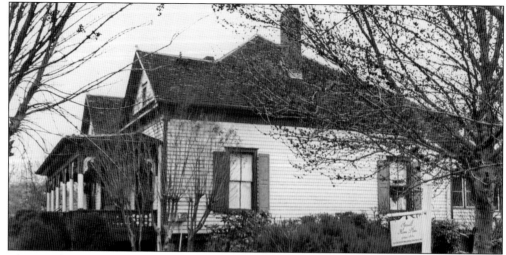

The Spruill home on Ashford Dunwoody Road was built in 1867. In 1905, Stephen Spruill and his wife, Mollie Lee Carter Spruill, moved their family from a log cabin farther back on the property to this house. Over the years it was modified to become a white Victorian farmhouse with four rooms and a central hallway. It is said that family valuables were hidden in a cellar under the smokehouse during the Civil War. Today the home serves as the Spruill Center for the Arts. (Photograph by Valerie Biggerstaff.)

Calhoun Spruill, son of Millie Jane Adams and James Spruill, married Mary Jane Copeland. James Spruill was the first Spruill to settle in Dunwoody. Calhoun and Mary Jane had four boys and two girls. Their daughter, Effie Spruill, married Ambrey Carpenter. (Courtesy of the Anderson family.)

Two

1900s HOMES AND PEOPLE

Glenn Greer Austin and Nettie Southern Austin posed for this marriage photograph in 1906. Their marriage took place on December 25 and was the first held in the newly organized Dunwoody Methodist Church. The couple first lived in a home on Austin family land in Sandy Springs near the Chattahoochee River. Their first child, Gladys, was born there. Daughter Nettie Mae Austin Kelley remembers her mother talking about being frightened that the baby carriage would roll into the Chattahoochee River. (Courtesy of the Austin family.)

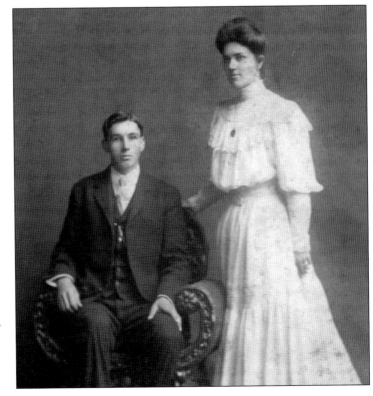

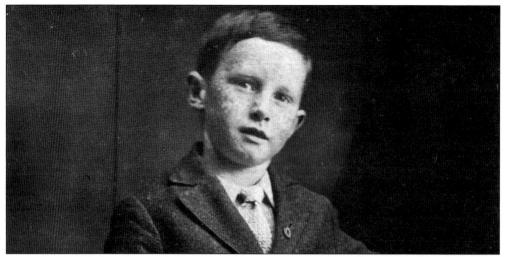

This young member of the Carpenter family is Harvey Carpenter, son of Cicero and Matt Carpenter. In the mid-1940s, Harvey and his wife, Dorothy, owned the store and post office at the intersection of Mount Vernon Road and Chamblee Dunwoody Road. (Courtesy of the Anderson family.)

The Austin family home was built in 1924 on land on the north side of Mount Vernon Road. Glenn G. and Nettie Southern Austin built it to accommodate their family of six children. Timber was cut from their own land for the home. The address of the home was 1200 Mount Vernon Road, but all that was needed for mail delivery was a name and "Dunwoody, Georgia." (Courtesy of the Austin family.)

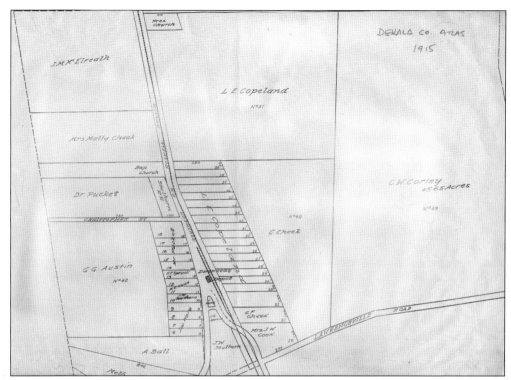

This 1915 map of Dunwoody shows who the property owners were in the center of the community. Today's Mount Vernon Road was then called Lawrenceville Road. The Dunwoody Depot and the path of the railroad (here identified as the "Southern Railroad Roswell Branch") are both shown. The area labeled "Southern Railroad" is where the railroad section houses were located. Dr. Pucket owned land behind these. The Dunwoody Baptist Church was located next to the section houses, and New Hope Presbyterian Church is shown farther north. Dunwoody Methodist Church is at the bottom of the map. (Courtesy of Jim Perkins.)

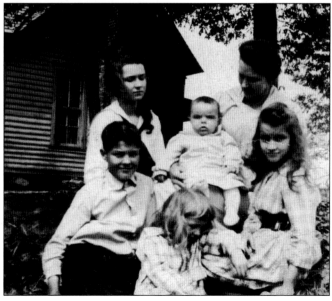

Nettie Southern Austin poses in 1920 in front of the family home with five of her children. She and Glenn Greer Austin eventually had six children. Clockwise from center are baby Glenn with mother Nettie, Sarah, Nettie Mae, John, and Gladys. (Courtesy of the Austin family.)

33

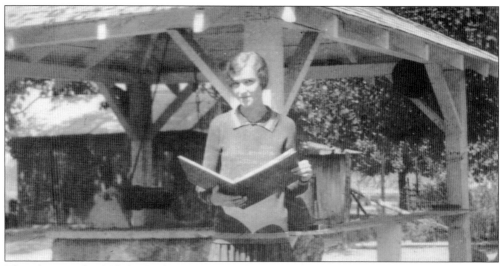

This photograph of Gladys Ruth Austin was taken around 1922 in front of the well at the family home place. Gladys was born in 1907, attended Agnes Scott College, and was a teacher in Atlanta schools. (Courtesy of the Austin family.)

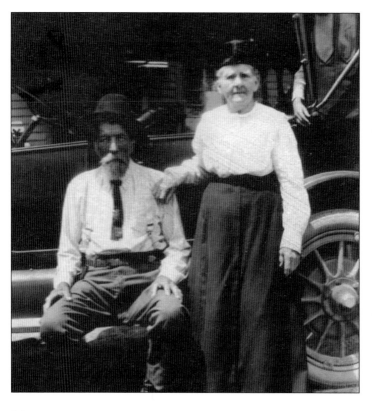

This 1920s photograph of John and Sally Southern features the family Studebaker. John W. Southern (1848–1924) was born in South Carolina. Sarah E. Jenkins Southern (1841–1924) grew up in Atlanta with many close relatives whom she cherished going to visit. Nettie Mae Austin Kelley, granddaughter of John and Sally Southern, recalls the family history that "one night during the Civil War a shell exploded in the living room where her [Sally's] family sat. They left Atlanta at night in an open wagon with few possessions and fled to Macon." (Courtesy of the Austin family.)

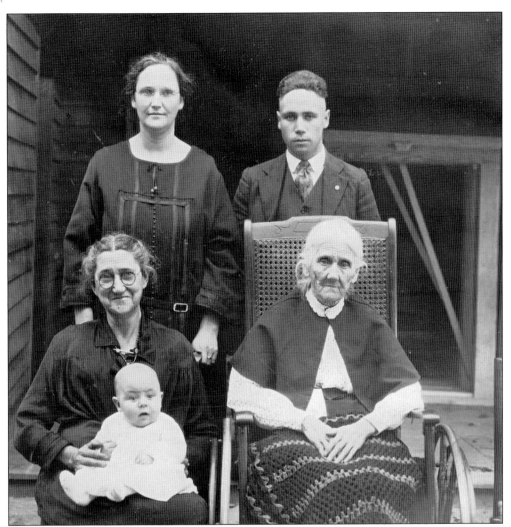

The woman at the bottom left of this photograph is Mary Jane Copeland, and she is holding her grandson Edward Blackburn. To the right of her is her mother and the baby's great-grandmother, Salina Copeland. Salina and Obediah Copeland lived on a plantation on Roberts Drive, where Dunwoody Springs Elementary School is today. Pictured from left to right on the second row are Liza Spruill Blackburn and Charlie Blackburn. The Blackburn home sat on Chamblee Dunwoody Road, where Dunwoody Hall shopping center is today. Their home was the parsonage for Dunwoody Baptist Church when it was located on Chamblee Dunwoody Road. (Courtesy of the Anderson family.)

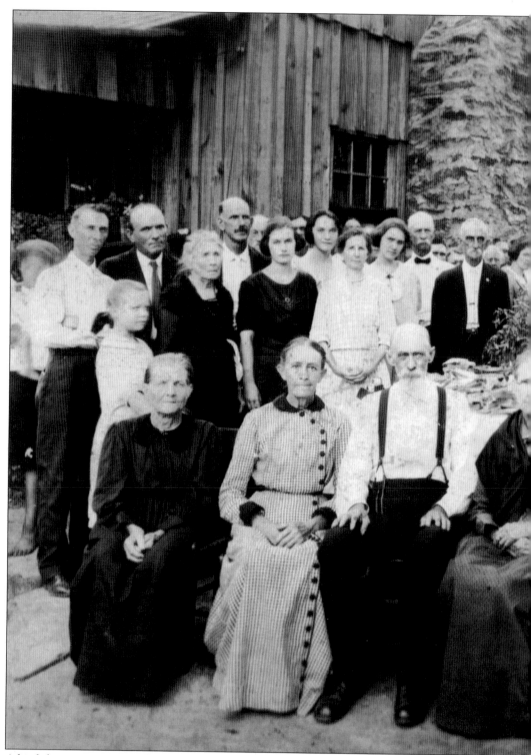

A birthday party occasioned this 1925 picture. Seen here (in no particular order) are Effie Spruill Carpenter, Ambrey Carpenter, Jane Carpenter Ball, Frances Owen Carpenter, Amanda Carpenter,

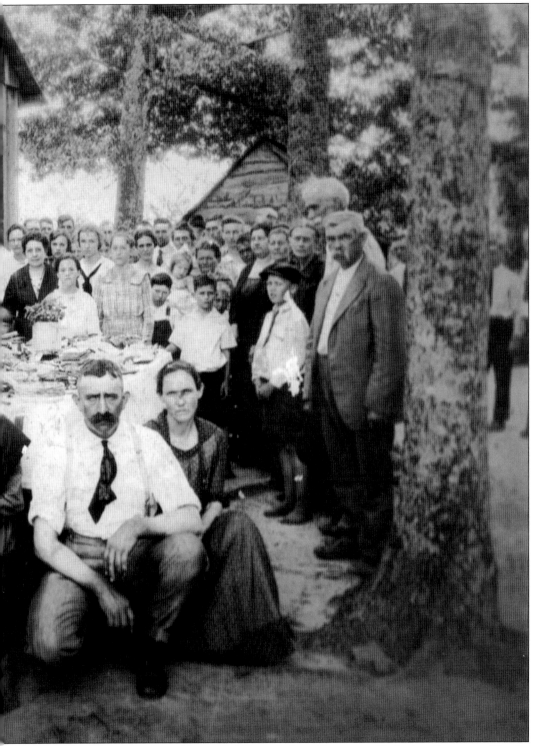

Mrs. Donaldson, Tobe Donaldson, Mr. Womack, Lucy Carpenter, Katherine Carpenter, Charlie Blackburn, and Lon Eidson. (Courtesy of the Anderson family.)

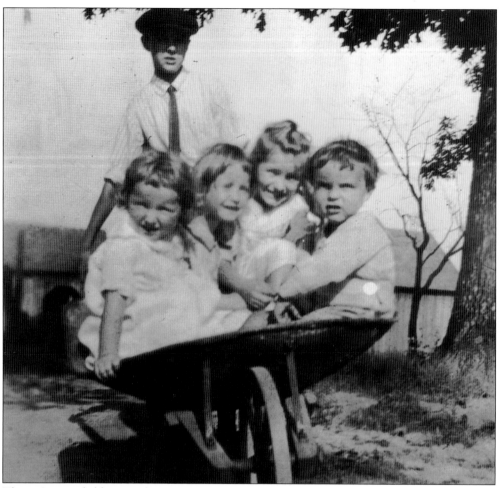

These Austin children are having a great time being pushed around in a wheelbarrow in the 1920s at the Austin home place. The boy in the wheelbarrow on the right is Glenn Austin, and behind him is Nettie Mae Austin. (Courtesy of the Austin family.)

Glenn Austin often worked with the youth of the Dunwoody Methodist Church. This photograph was taken around 1936, when he was 16 years old. (Courtesy of the Austin family.)

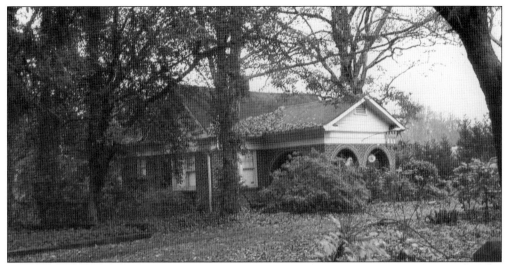

Boyce Eidson and his brother Zechariah sired some of the pioneer families of Dunwoody. Zechariah Eidson donated the land where Dunwoody Grammar School was located; Boyce Eidson donated the land for a cemetery on Winters Chapel Road. This photograph shows the first brick residence completed in Dunwoody, the home of Lon Eidson, grandson of Boyce. He owned a store and filling station on Chamblee Dunwoody Road in the same area as the house. (Photograph by Valerie Biggerstaff.)

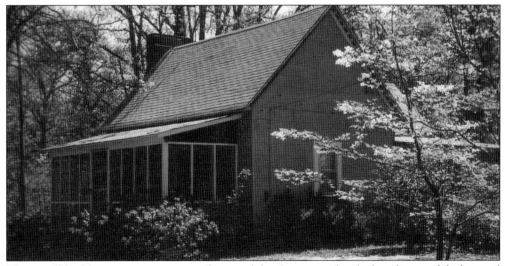

This small building was once a tenant house of the Carpenter family, but they modified it, and Walter Anderson and Lucy Carpenter Anderson moved into it in 1929. It was located on the southwest corner of the intersection of Tilly Mill Road and Mount Vernon Road. (Courtesy of the Anderson family.)

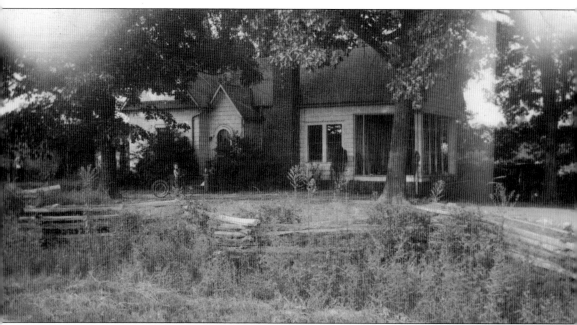

This home was built about 1916 by the Ware family and was purchased by the Renfroes around 1925. Mrs. Renfroe said she would not live in the home permanently until the road was paved. After Tilly Mill Road was paved in 1930, the Renfroes moved in. Carlton Renfroe still lives in this home today. The side porch has been enclosed and the split rail fence is no longer there, but otherwise, the home looks very much the same as it does here. (Courtesy of the Renfroe family.)

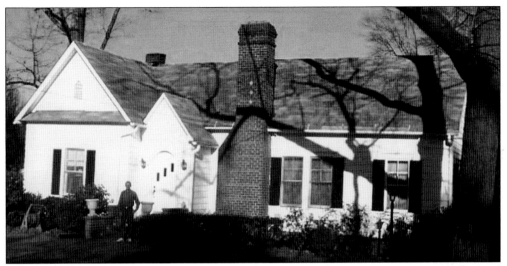

This is how the Renfroe home place looks today. The Renfroe Lake subdivision was added behind the home several years ago. Carlton Renfroe's brother Bogan, using a single backhoe, dug out the lake a little at a time. (Photograph by Valerie Biggerstaff.)

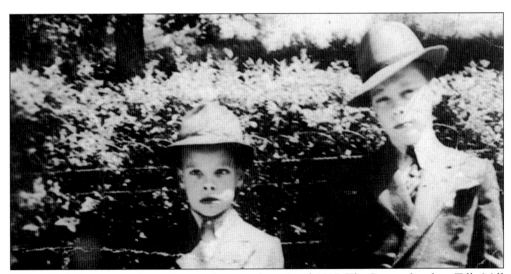

Bill and Jeff Porter pose for an Easter photograph in April 1937. The Porters lived on Tilly Mill Road across the street from the Renfroes. Carlton Renfroe and Jeff Porter remain friends to this day and get together regularly. (Courtesy of the Porter family.)

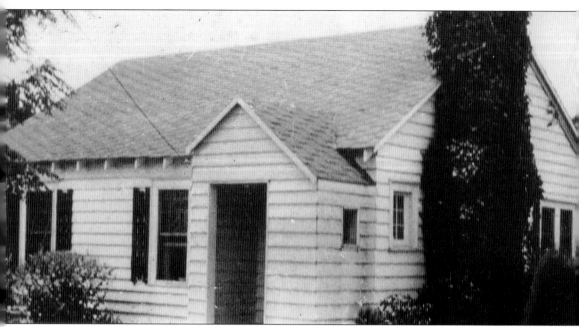

This home belonged to the Nash family and later to the Prices. It was near the intersection of Chamblee Dunwoody Road and Mount Vernon Road, behind where a grocery store and the post office stood. The grocery store was run by the Nash family. Later the store was operated by the Carpenter, Brown, and Thompson families. (Courtesy of the Anderson family.)

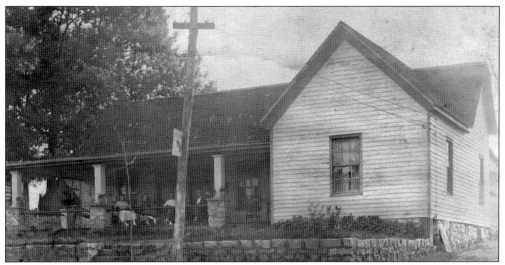

In the 1930s, the P. L. Moss home and store stood about where the *Dunwoody Crier* office stands today at the fork of Chamblee Dunwoody Road and Nandina Lane. To the left of this home was the Howingtons' residence, and to the right was the Hendersons'. This house was knocked down in the 1970s. (Courtesy of the Anderson family.)

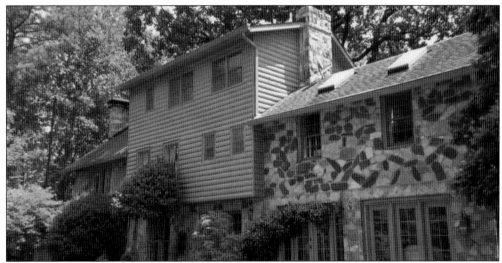

William Gordon Geffcken purchased 23.14 acres in Milton County in 1931 and planned to build a home on the land. Unfortunately, between the Great Depression and problems with contractors, Geffcken was unable to complete the home until around 1941. After renting it out for a few years, the Geffckens finally moved into the home in 1946. The house was built on a high point and nicknamed "Kenstone;" in those days, from the property one could see both Stone Mountain to the southeast and Kennesaw Mountain to the northwest. (Photograph by Valerie Biggerstaff.)

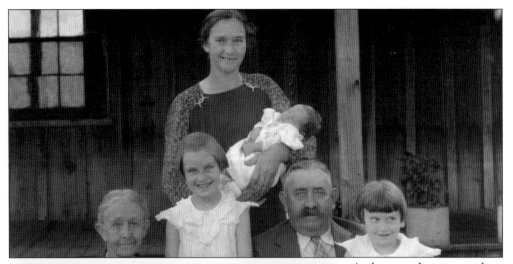

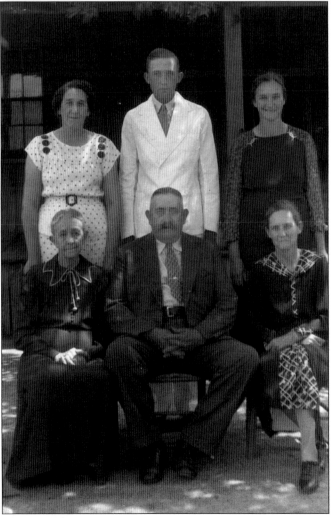

A photographer captured members of the Carpenter and Anderson families in 1937. Pictured from left to right are Amanda Carpenter, Carolyn Anderson Parker, Ambrey Carpenter, and Jane Anderson Autry. The woman standing is Lucy Carpenter Anderson holding new baby boy Walter K. Anderson. (Courtesy of the Anderson family.)

Members of the pioneer Carpenter family pose in front of their home at Tilly Mill Road and Mount Vernon Road. Pictured are, from left to right, (first row) Amanda Carpenter, Ambrey Carpenter, and Effie Spruill Carpenter; (second row) Kathryne Carpenter, Ambrey Carpenter Jr., and Lucy Carpenter Anderson. (Courtesy of the Anderson family.)

Glenn Austin built a home place for his family in the 1940s on Austin property along Mount Vernon Road. He and his father cut the timber for the home, and the split-rail fence was built by Glenn Austin's grandfather, John Southern. The day this picture was taken was a rare snow day for Dunwoody. (Courtesy of the Austin family.)

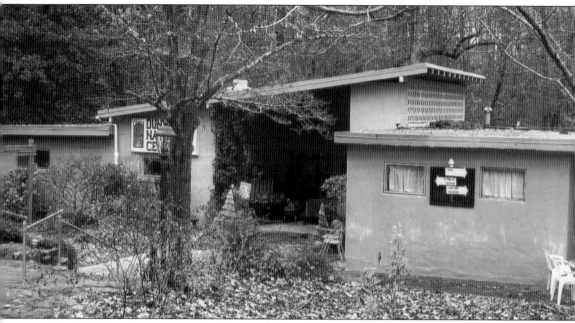

The T. K. Peters home is now the Dunwoody Nature Center. Peters was an inventor, collector, and filmmaker. He and his wife, Grace, built the home in 1945. They placed a large millstone they found on the property at the front of the house. A mill once stood on Wild Cat Creek, which runs through the property. (Photograph by Valerie Biggerstaff.)

A chimney and foundation still remain behind the T. K. Peters Home. These are probably from the home of a tenant farmer built in the early days of Dunwoody. (Photograph by Valerie Biggerstaff.)

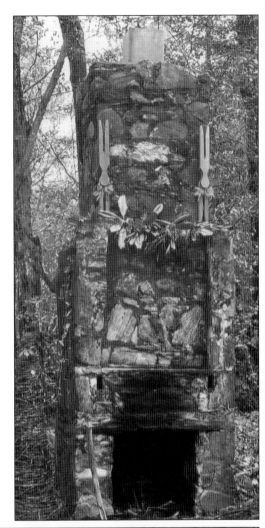

This millstone sits behind the old Peters home, which is now the Dunwoody Nature Center. The stone was once mounted in front of the house. (Photograph by Valerie Biggerstaff.)

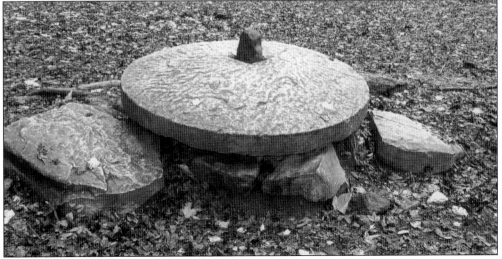

Samuel Hewlett, an Atlanta judge, built this summer home near the Chattahoochee River. Hewlett Road off Spalding Drive once led to the home but is now a street of homes that dead-ends. The home is now an office for the Chattahoochee National Recreation Area as part of the Island Ford Park. Island Ford Park is accessible from Roberts Drive. (Photograph by Valerie Biggerstaff.)

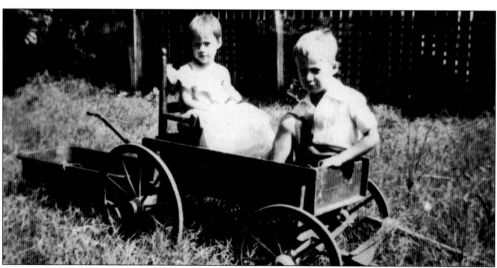

This photograph was taken about 1936 at the Renfroe home. Siblings Carlton Renfroe and Esther Renfroe are seen enjoying some time in their wooden wagon. (Courtesy of the Renfroe family.)

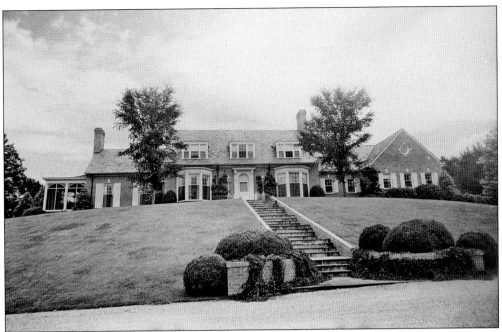

Tom Bailey built a home off Spalding Drive in the early 1930s and later decided to make it his permanent home. The photograph below shows tenant house he had built on the property. Bailey tried to make the residence as self-sustaining as possible. (Both courtesy of Georgia State University).

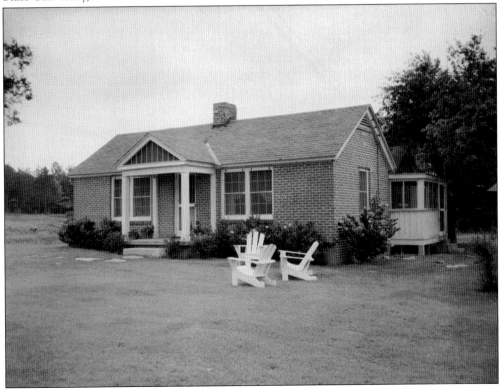

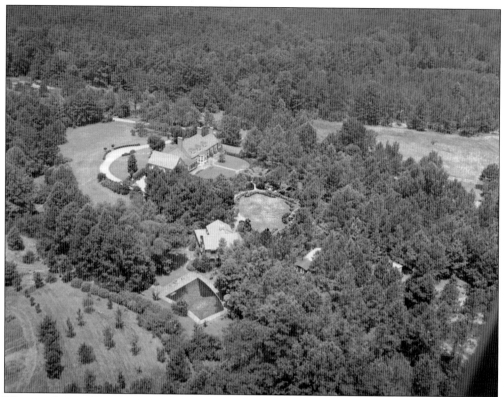

This aerial view of Tom Bailey's estate shows how extensive it was. The house stands today amidst the Bailey Estates subdivision, which was built around it. (Courtesy of Georgia State University.)

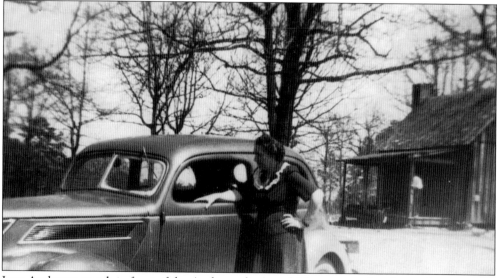

Jane Anderson stands in front of the Anderson home, which once stood at the southwest corner of Tilly Mill Road and Mount Vernon Road. The photograph was taken in 1947; the car is a 1937 Ford. (Courtesy of the Anderson family.)

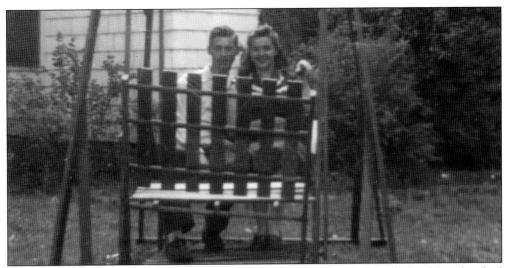

Carlton Renfroe and his cousin sit outside the Renfroe home on Tilly Mill Road. Renfroe had recently returned from serving in the Korean War. (Courtesy of the Renfroe family.)

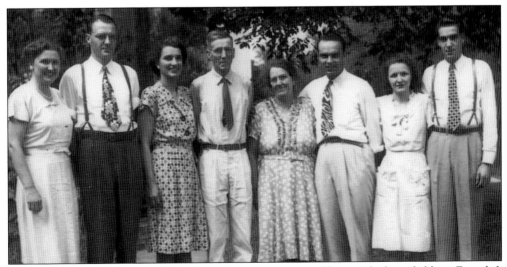

Nettie Southern Austin and Glenn Greer Austin are pictured here with their children. From left to right are Gladys Austin, John Austin, Sarah Austin, Glenn G. Austin, Nettie Southern Austin, Glenn T. Austin, Nettie Mae Austin, and Eddie Austin. (Courtesy of the Austin family.)

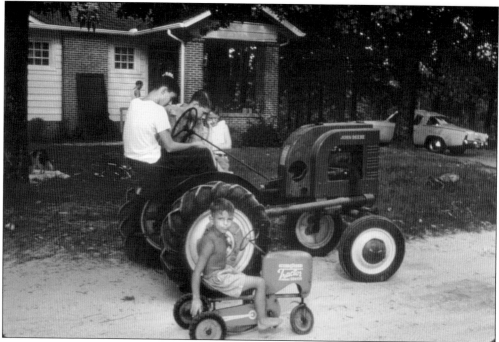

A real tractor and a toy tractor appear in this picture taken at the Austin home in the 1950s. Glenn T. Austin is pictured on the toy tractor. Pictured with a 1939 John Deere front-crank tractor are, from left to right, Randy Austin, John Austin Jr., and Betsy Austin. (Photograph by Ellis Mann, courtesy of the Austin family.)

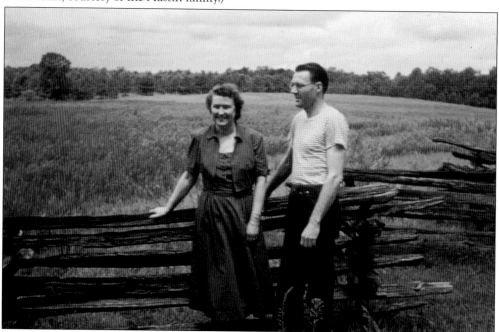

When Gladys and John Austin were photographed standing by this split rail fence, Dunwoody was still mostly undeveloped. The land behind them would later be the sight of the Trailridge subdivision. (Courtesy of the Austin family.)

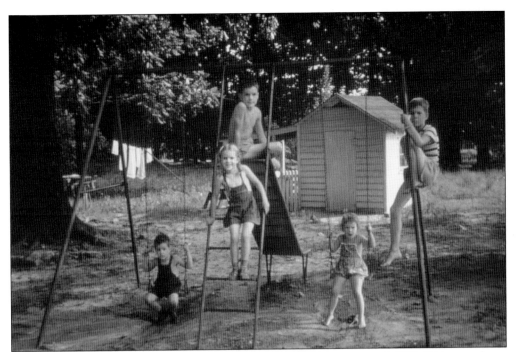

This is another Austin family photograph, taken by Ellis Mann around 1950. This one shows the children playing on their swing set with their playhouse, built by their grandfather Glenn G. Austin, in the background. (Courtesy of the Austin family.)

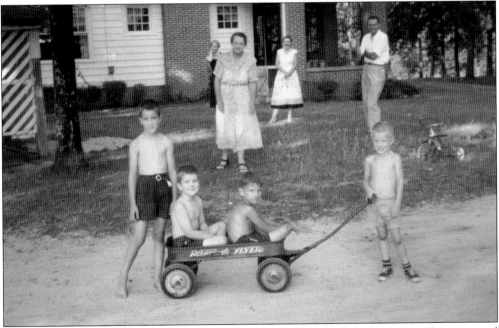

Ellis Mann took this photograph of the Austin family and their Radio Flyer wagon. Those pictured include, from left to right, (first row) Randy Austin, Chris Austin, Glenn T. Austin, and Alan Kelley; (second row) Ruth Austin, Nettie Southern Austin, Gladys Austin Mann, and John Southern Austin. (Courtesy of the Austin family.)

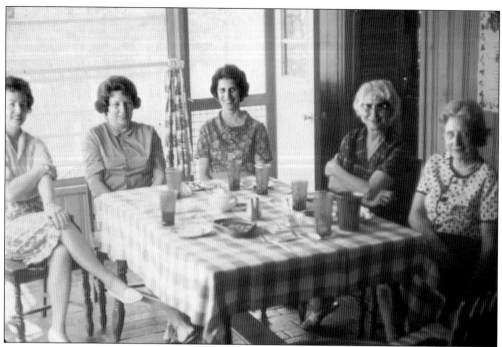

Some of the women of the Dunwoody Methodist Church are shown having tea on the porch of Paula and Jim Warnes. Paula Warnes is seated in the center. This picture was taken by the minister at the time, Rev. Jack Bozeman. (Courtesy of the Austin family.)

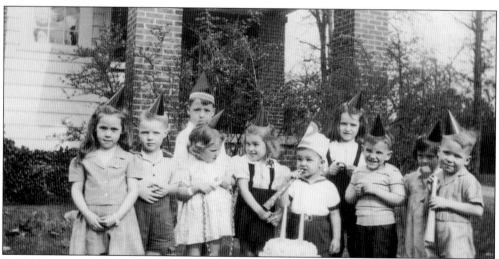

In 1945, a group of Dunwoody children gathered for the second birthday party of George Zorn Jr. George was the first child of Sarah and Rev. George Zorn. This photograph was taken in front of the Austin home place. (Courtesy of the Austin family.)

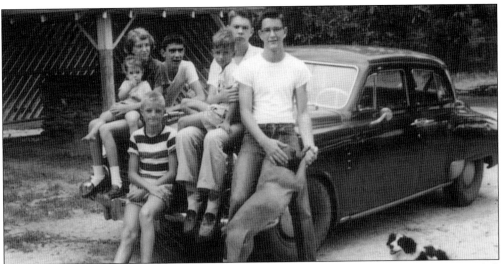

These children have gathered on the hood of a car. The dogs are Lucky and Ginger. From left to right are Betsy Mann holding Suzanne Austin, Bill Mann, Glenn Austin, John Austin, and Randy Austin. Ken Kelley is sitting on the bumper in front. (Courtesy of the Austin family.)

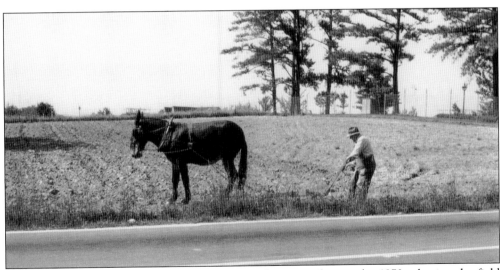

Carey Spruill and his mule Shorty were frequently seen as late as the 1970s plowing the field behind the Spruill/Cheek Farmhouse. On occasion, Spruill and Shorty coming out into the road to turn around and plow another row held up traffic along Mount Vernon Road. (Courtesy of Dunwoody Preservation Trust.)

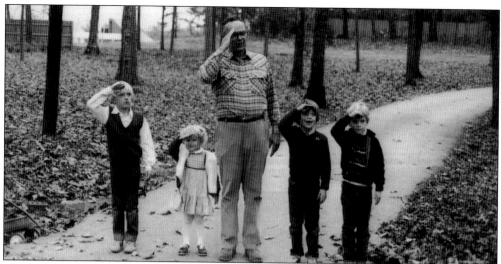

Glenn Austin is pictured with his grandchildren at the Austin home place at 1418 Mount Vernon Road. He and the children had a Thanksgiving tradition: first, they would march up to the flag while he called out "hup-two, hup-two," followed by "about face." Next, Glenn would call "Attention!" Then they would all salute the flag. From left to right are Ryan, Amy, Stephen, and Glenn III. (Courtesy of the Austin family.)

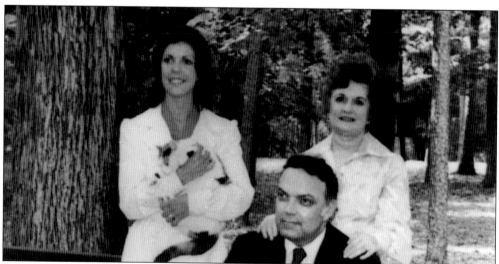

Suzanne Austin Carley provided many family and church pictures for this book. She is shown here with the family cat Chiefie and her parents at their home on Mount Vernon Road, in the area across from the Dunwoody Baptist Church. (Photograph by Manget Davis, courtesy of the Austin family.)

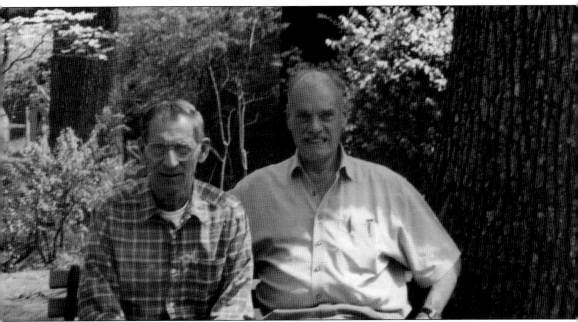

Carlton Renfroe and Jeff Porter became friends in the 1930s and 1940s, when they lived across the road from each other on Tilly Mill Road. This recent photograph was taken at Carlton Renfroe's family home, which still remains on Tilly Mill Road. The two childhood friends still get together regularly. (Courtesy of Carlton Renfroe.)

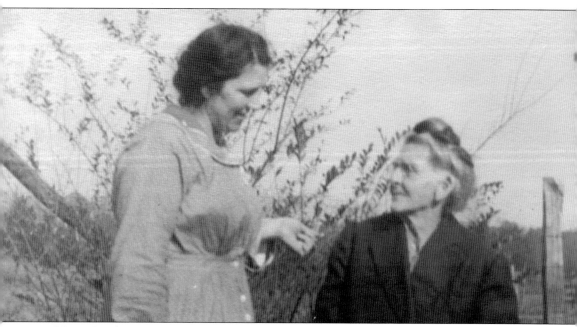

Nettie Southern Austin and her mother, Sally Southern, are shown together in the garden of the Austin home place. The home was next door to the early Dunwoody Methodist Church. John and Sally Southern encouraged their only daughter to seek a higher education and sent Nettie to Athens to attend Georgia State Normal School. When she returned, she became a teacher for the community. As is evident in this image, Dunwoody was as yet undeveloped. (Courtesy of the Austin family.)

Three

THE ROSWELL RAILROAD

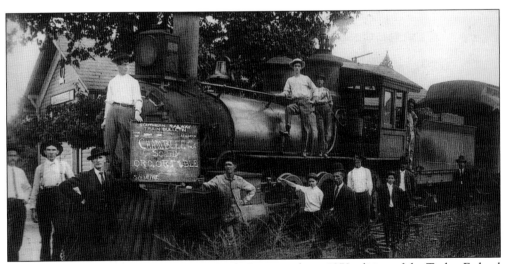

This photograph of the train known as "Dinky" appeared in a 1972 edition of the Tucker Federal Savings and Loan newsletter. The engine was stopped at the Chamblee Station at the time. Oma Elliott Woodall identified her father, Dave Elliott, as the man standing and wearing a derby hat. In the article, B. C. Spruill said "That whistle used to wake me in the morning when it came in front of my house." Later he worked on the train for five years. The man standing in the cab of the train is the engineer, Isaac (Ike) Roberts. Standing on the far right is John Southern. (Courtesy of the Anderson family.)

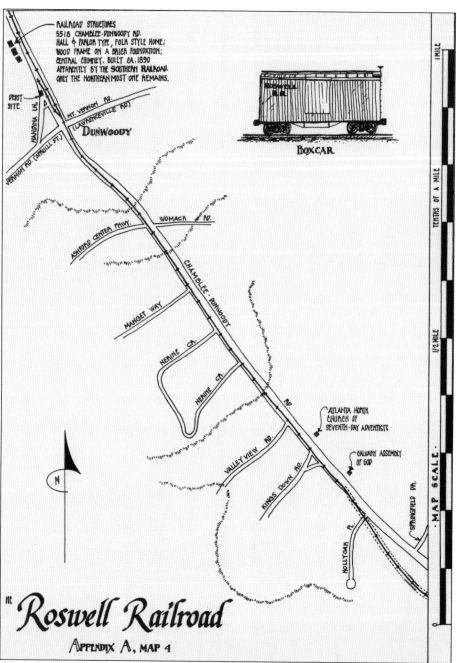

RAILROAD STRUCTURES
5518 CHAMBLEE-DUNWOODY RD.
HALL & PARLOR TYPE, FOLK STYLE HOME;
WOOD FRAME ON A BRICK FOUNDATION;
CENTRAL CHIMNEY. BUILT CA. 1890
APPARENTLY BY THE SOUTHERN RAILROAD.
ONLY THE NORTHERN MOST ONE REMAINS.

DEPOT SITE

NANDINA LN.

MT. VERNON RD.
(LAWRENCEVILLE RD.)

DUNWOODY

VERNON RD. (SPRUILL ST.)

BOXCAR

ASHFORD CENTER PKWY.

WOMACK RD.

CHAMBLEE-DUNWOODY RD.

MANGET WAY

NENINE CR.

NENINE CR.

VALLEY VIEW RD.

KINGS DOWN RD.

HOLLYOAK RD.

SPRINGFIELD DR.

ATLANTA NORTH
CHURCH OF
SEVENTH-DAY ADVENTISTS

CALVARY ASSEMBLY
OF GOD

N

· MAP SCALE ·

1 MILE

TENTHS OF A MILE

1/2 MILE

0

The **Roswell Railroad**

APPENDIX A, MAP 4

Michael Hitt researched the path of the Roswell Railroad and came up with several detailed maps. This section shows the modern-day roads and churches that are close to where the railroad once was. The train's path led right through the center of Dunwoody along where Chamblee Dunwoody Road is today. The Roswell Railroad was narrow-gauge track until about 1908, when it became standard track. In 1905, Pres. Theodore Roosevelt came by train to Chamblee, then boarded the Dinky and rode to Roswell. The trip was more than a campaign whistle stop: Roosevelt's wife, Martha Bulloch Roosevelt, was from Roswell, so they came back for a visit. (Courtesy of Michael Hitt.)

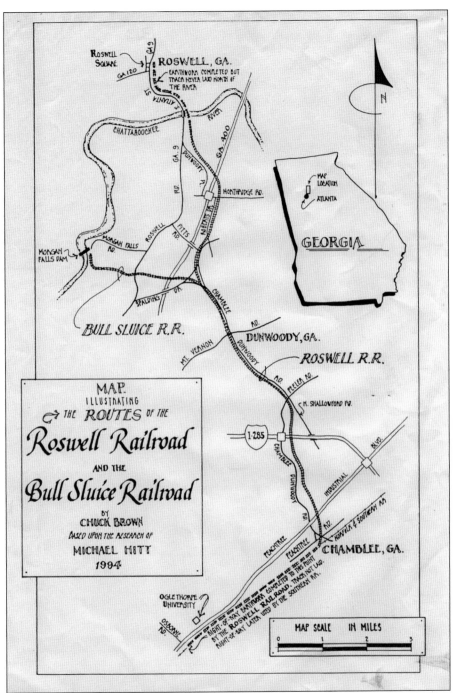

Roswell historian Michael Hitt and illustrator Chuck Brown developed this map of the Roswell Railroad in 1994. The map shows the path the train followed between Chamblee, Georgia, and Roswell, Georgia. The center part of the map includes Dunwoody. The Bull Sluice was a line that went to Morgan Falls Dam in the early 1900s, carrying supplies to build the dam. Stories tell of how the train (called "Dinky" or "Buck") would stop to pick up passengers if they flagged it down. (Courtesy of Michael Hitt.)

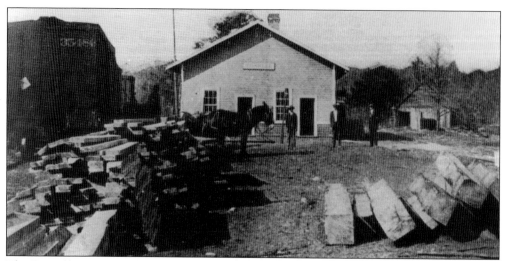

The Roswell Depot stood on the south side of the Chattahoochee River. Buggies would come across the bridge to deliver or pick up passengers. The Roswell Railroad departed from this point and went through Dunwoody and on to Chamblee, Georgia. The train ran for 40 years, from 1881 to 1921. (Courtesy of the Anderson family.)

When the Roswell Railroad passed through Dunwoody, groups of railroad employees, known as section gangs, worked on the railroad. Some workers lived in section houses built near the track. Dunwoody had three section houses, all located on Chamblee Dunwoody Road just across from the depot. Only one house remains today. (Courtesy of the Carpenter family.)

The Ike Roberts home still stands today on Roberts Drive, which was named for him. The home is in Fulton County, near Roswell Road. Ike Roberts was the conductor of the Roswell Railroad from 1881 until 1921. His home was near the Roswell Depot, which stood on a hill just south of the Chattahoochee River. Plans originally called for a bridge over the Chattahoochee into the town of Roswell, but that never happened. (Courtesy of Michael Hitt.)

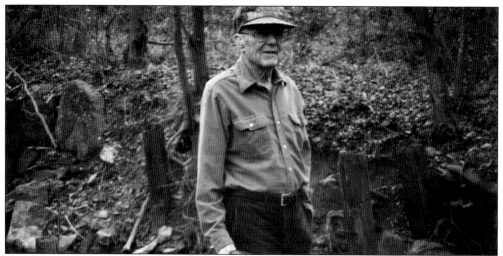

In 1993, Gordon Wallace helped Dunwoody history columnist Jim Perkins and Roswell historian Michael Hitt locate the remains of a railroad trestle bridge that once spanned Nancy Creek in Chamblee. Dinky went over this bridge on its journey from Chamblee to Roswell twice each day between 1881 and 1921. Gordon Wallace remembered the days of the train passing through Dunwoody. (Photograph by Michael Hitt.)

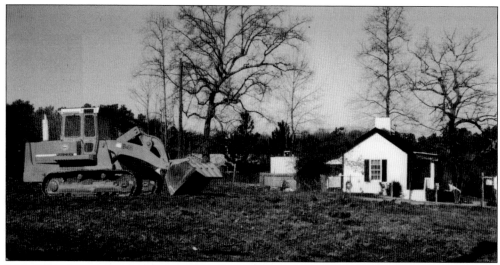

This 1994 photograph shows the remaining railroad section house and a bulldozer soon after the other two section houses had been torn down. Dunwoody historian Jim Perkins asked the construction workers to be on the lookout for remnants of the Roswell Railroad, and two rails were found. Longtime resident Ken Anderson recalls that the other section houses were duplexes. (Photograph by Michael Hitt.)

Four

SCHOOLS

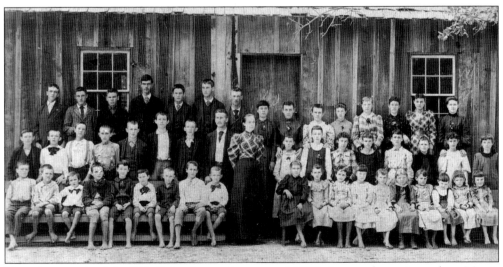

This photograph of the Tilly School was taken around 1900. Among those pictured are Mattie Donaldson Carpenter (first row, fifth from right) and Ambrey M. Carpenter (first row, fourth from left). This school was located where Tilly Mill Road and Peeler Road come together and was named for the Tilly family, which owned the surrounding land and mill. (Courtesy of the Anderson family.)

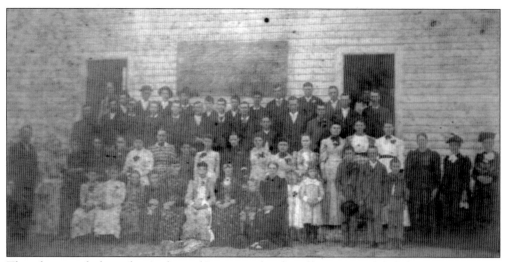

This photograph from the Anderson/Carpenter family collection was labeled "singing school." It is dated August 11, 1892, but the location shown in the image is unknown. It could be an early picture at the Dunwoody School, Tilly School, or Chestnut Ridge School. (Courtesy of the Anderson family.)

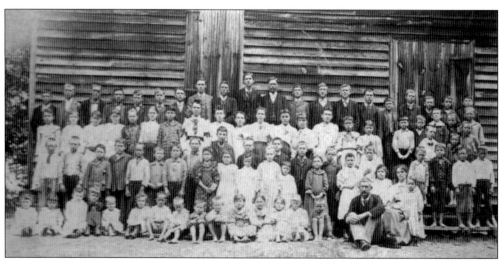

This photograph is also not identified, but it was among old pictures found by Ken Anderson in his family photographs. It appears to be a school also, but the location is unknown. (Courtesy of the Anderson family.)

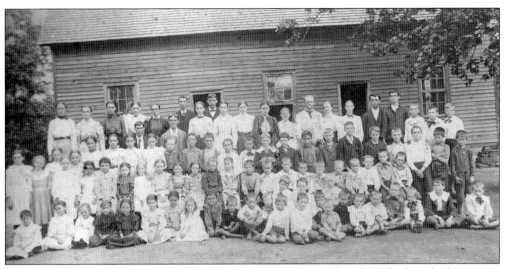

This 1898 photograph was taken in front of the original Dunwoody School, built in the late 1800s. Standing in the back row, eighth from the left and in front of a window, is Ambrey Carpenter Sr. (Courtesy of the Anderson family.)

Gladys and Ernest Ware appear in this photograph taken outside of the school, probably around 1910. The Ware family lived on what is now Dunwoody Club Drive near where it meets Mount Vernon Road. (Courtesy of the Ware family.)

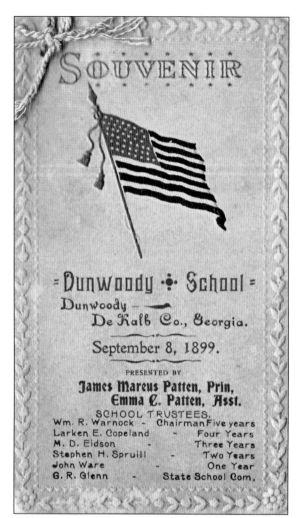

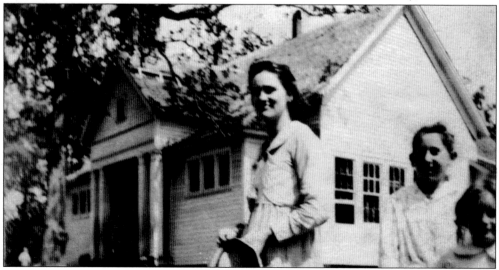

Here is a school souvenir program from September 8, 1899. This school program cover shows the trustees for the school, which include many of the pioneer families of Dunwoody. They are Warnock, Copeland, Eidson, Spruill, and Ware. Inside are the names of the students from each grade that year. (Courtesy of the Anderson family.)

This 1920s photograph of three young people standing in front of the school includes Kathryne Carpenter in the center. (Courtesy of the Anderson family.)

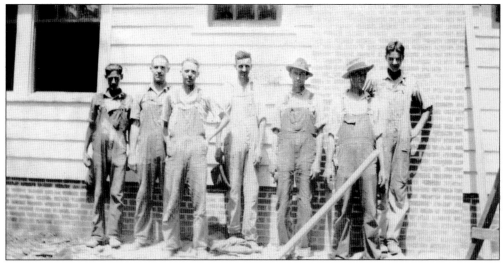

This group of Dunwoody men helped build a new grammar school in 1921. The new school was a white wooden building that remained in use until about 1935, when it was replaced with a brick building. Standing in the middle is Glenn Greer Austin. (Courtesy of the Austin family.)

These four lovely young women in nice dresses are probably celebrating their graduation from the Dunwoody School. (Courtesy of the Austin family.)

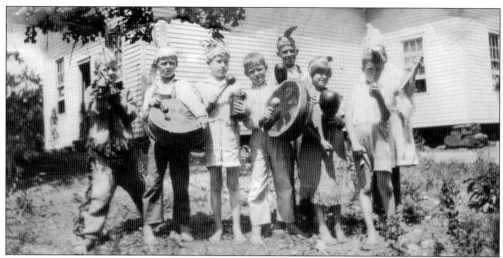

This group of children is standing in front of the 1920s version of Dunwoody School. They seem to be having an "Indian" celebration, with headdresses and drums. (Courtesy of the Austin family.)

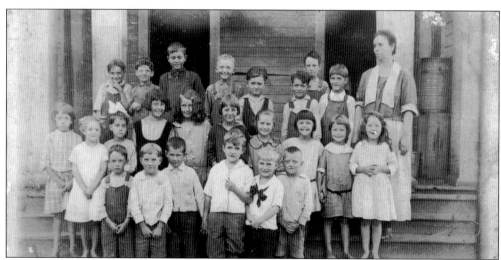

The children of Dunwoody School are shown here in 1921. They include Ambrey Monroe Carpenter Jr., pictured in the middle of the back row. (Courtesy of the Anderson family.)

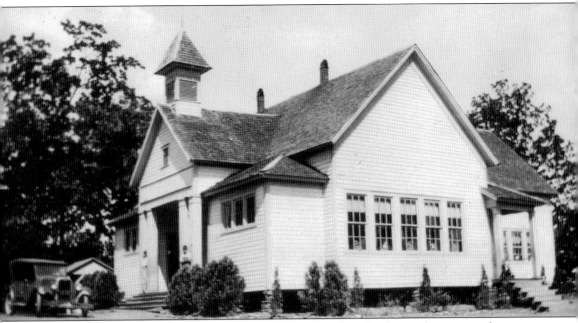

There have been four different variations of the Dunwoody School over the years in the same location on Chamblee Dunwoody Road. The first one-room school house was built in the late 1800s. The second, the white wood building pictured here, was built the 1920s. In the 1930s, a brick building was built, and in the 1960s, a more modern building was constructed. The last school is now used as the Dunwoody Library. In 2009, a new school with the name Dunwoody Elementary School opened on Womack Road. (Courtesy of the Austin family.)

One of the toys the children of Dunwoody School played with was a sand table built by Glenn Greer Austin. He was the husband of Nettie Austin and a very skilled carpenter. Many wooden toys were available to the students thanks to Glenn Austin. (Courtesy of the Austin family.)

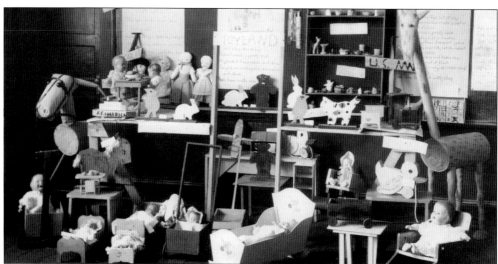

The sign in the back says "Toyland." These are some of the wooden toys that Glenn Austin made for the children of Dunwoody School. Among the wooden toys are a giraffe, baby beds, baby carriages, pull toys, and trucks. The small rocking chair in the lower right corner was made by J. D. Jordan. (Courtesy of the Austin family.)

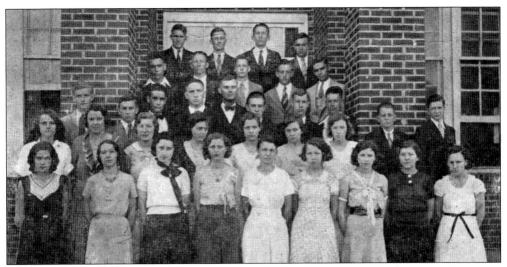

This class picture was taken at Chamblee High School in 1932. Dunwoody didn't have its own high school at the time, so children went to nearby Chamblee for high school. (Courtesy of the Anderson family.)

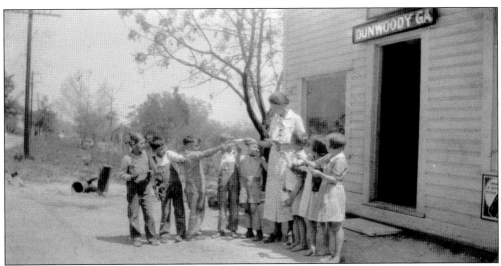

Nettie Austin takes a group of students from the school on a field trip to the local post office. The post office was just down Chamblee Dunwoody Road and occupied the former Dunwoody train depot. The children are handing their letters to Austin. The post office was located between where a CVS pharmacy and a Chevron gas station sit today. (Courtesy of the Austin family.)

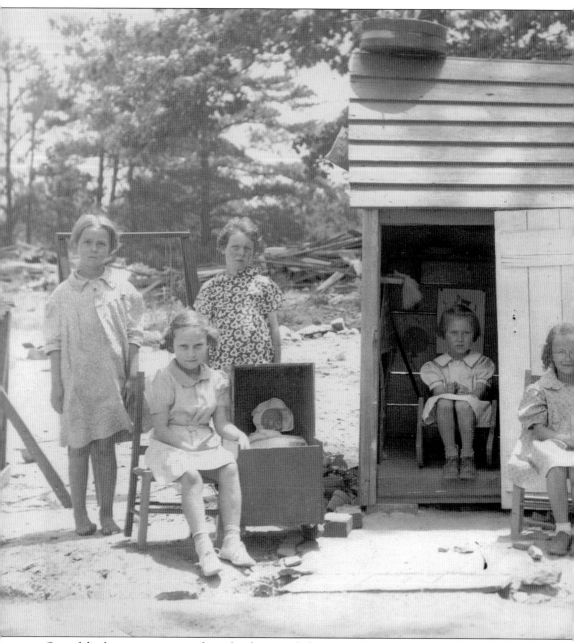

One of the favorite memories of people who attended Dunwoody School in the 1940s is the Dutch House. The small wooden house was built by Glenn Greer Austin, Nettie Austin's husband. Glenn was known to build many wooden toys for the school, as well as anything else the school needed,

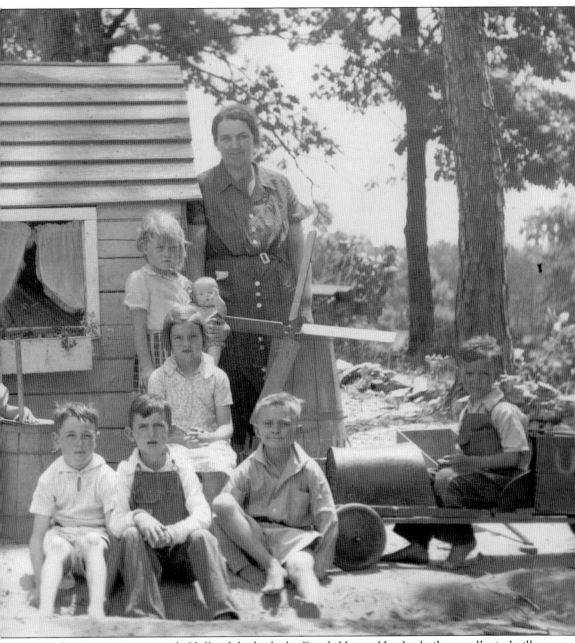

so when it was time to study Holland, he built the Dutch House. He also built a small windmill and wooden shoes to make the experience complete. (Courtesy of the Austin family.)

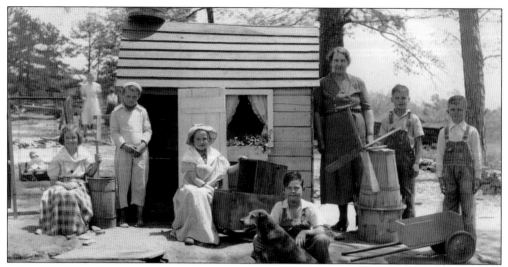

This is the same photograph of the Dutch House that is on the cover of this book. Some of the children are dressed in costume for their study of Holland. (Courtesy of the Austin family.)

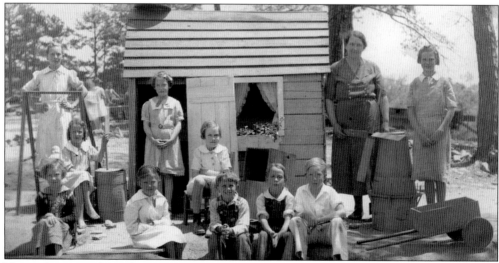

Nettie Austin and another group of children pose with the Dutch House. (Courtesy of the Austin family.)

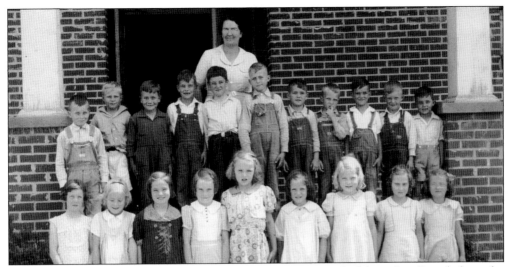

Dunwoody School students remember Nettie Austin as a wonderful teacher. Fourth from the left in the front row is Jane Anderson Autry, and sixth from the left in the back row is Archie Marchman. (Courtesy of the Austin family.)

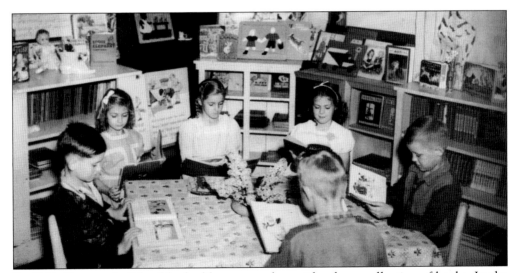

By 1944, Dunwoody School had a library complete with a large collection of books. In the 1930s, before the school library opened, children and adults relied on the bookmobile to come to Dunwoody in order to have something new to read. (Courtesy of the Austin family.)

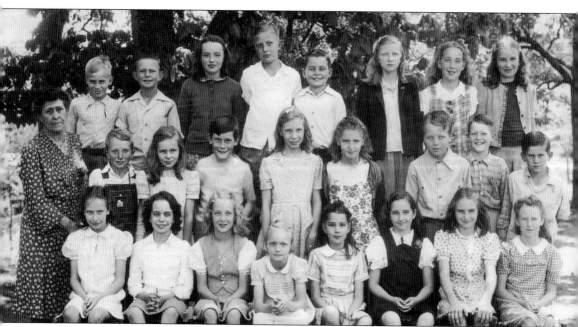

Beloved Dunwoody School teacher Mrs. Chambers poses with her class on the school grounds. Pictured from left to right are (first row) unidentified, Alice Porter, Joan Jameson, unidentified, Pat Payne, Joan Barrow, Ada Jackson, and unidentified; (second row) Mrs. Chambers, Ray Warbington, unidentified, Seaburn Wilkes, Alvilene Price, Virginia Adams, Leon Warbington, Ronald Spruill, and James Donaldson; (third row) James Renfroe, Harold Swancey, Peggy Beam, Thomas Manning, Robert Dale Long, Dorothy Adams, Juanita Marchman, and Betty Warbington. (Courtesy of the Anderson family.)

Around 1935, Dunwoody's second wooden school was demolished, and a new brick school was built for Dunwoody in the same spot as the previous school. This photograph was taken in 1944 for Nettie Austin's scrapbook. (Courtesy of the Austin family.)

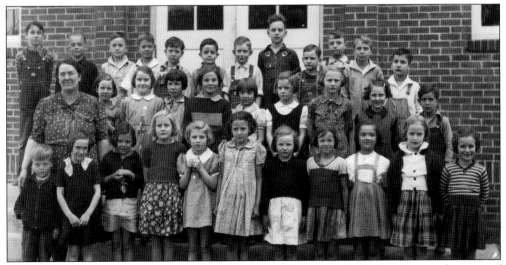

In 1941, the first-, second-, and third-grade classes of Dunwoody School gather on the steps of the auditorium for a photograph. Those identified are (first row) Leon Warbington (far left) and Margaret Ford (fourth from the left); (second row) Nettie Austin (far left), Jane Anderson Autrey (third from left), and Nora Adams (fourth from left); (third row) Calvin Warbington, Jeff Porter, Aubrey Blackburn, two unidentified, Pete Spruill, Travis Eidson, Bonnie Swancey, Gilbert Stringer, unidentified, Clarence Warbington, and unidentified. (Courtesy of the Anderson family.)

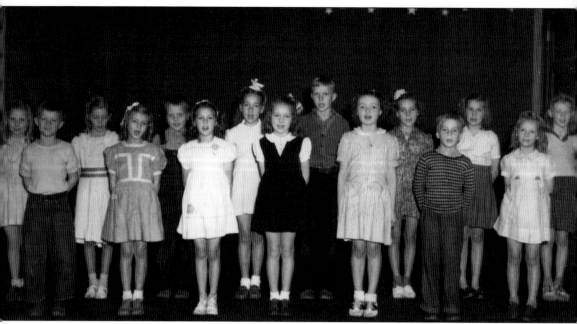

These students are part of the 1944 third-grade chorus at the Dunwoody School. Fifteen boys and girls participated in the chorus, singing at Christmas, "Daddies Night," and graduation. Some of the students pictured here are, in no particular order, Betty Warbington, James Renfroe, Peggy Beam, Barbara Marchman, Juanita Marchman, Leon Warbington, Virginia Adams, and Ronald Spruill. (Courtesy of the Austin and Anderson families.)

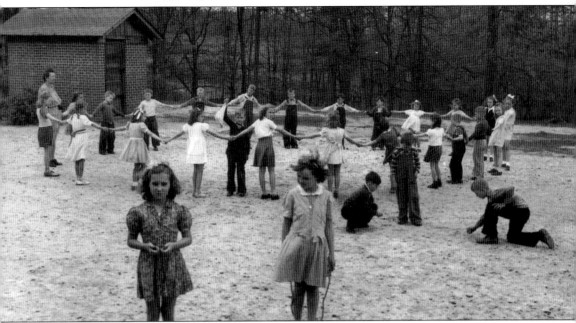

Teacher Nettie Southern Austin taught first-, second-, and third-grade students at Dunwoody School for many years. Here she is pictured playing games with the children in the school yard. The small building in the background is a well. Students on her class roll that year included James Ford, Kenneth Anderson, Sarah J. Adams, Patricia Spruill, Harold Swancey, J. D. Stringer, Betty Warbington, Juanita Marchman, Barbara Marchman, Peggy Beam, Annie Mae Jenkins, Thomas Manning, Ronald Spruill, Betty Lou Silvers, Jackie Howington, Aubrey Spruill, Jerry Ann Burell, Barbara Bellotte, Cecil Silvers, Dorothy Adams, Nomagene Turner, and Reba Ann Garrett. (Courtesy of the Austin family.)

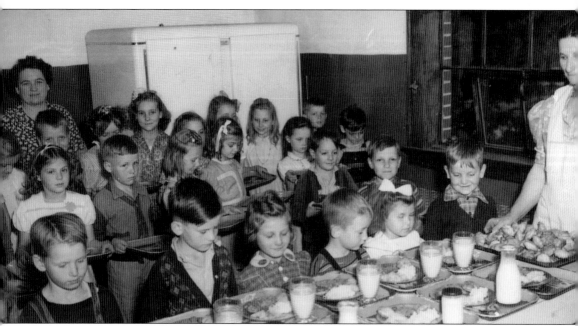

Dunwoody schoolchildren of the mid-1940s went to pick up their trays from a small kitchen and carried them back to their desks. Lunch was 15¢. The students pictured here include Jackie Howington, Jimmy Donaldson, Anne Renfroe, James Ford, Gerry Burrell, Ken Anderson, and Ola Womack Spruill; school principal Elizabeth Davis is in back. Nettie Austin took this photograph and placed it in her scrapbook. In her description, she noted that the hot lunches gave the children "good health" and "freedom from colds." (Courtesy of the Anderson family.)

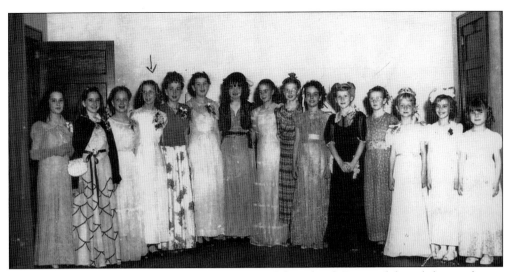

These young women are standing on the stage of the school. Pictured from left to right are Patricia Payne, Joan Barrow, Joan Jameson, Alvilene Price, Virginia Adams, Betty Washington, Peggy Beam, unidentified, Dorothy Adams, Alice Porter, two unidentified, Margaret Henderson, Corrine Borne, and Ann Renfroe. (Courtesy of the Anderson family.)

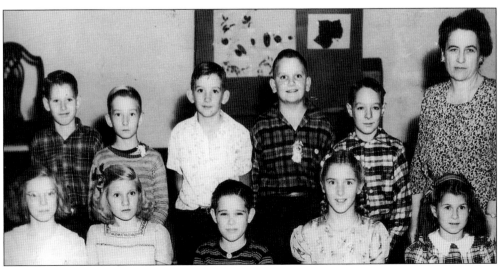

These Dunwoody school children are posing with teacher Elizabeth Davis. She was the school's principal from 1937 until 1962. (Courtesy of the Anderson family).

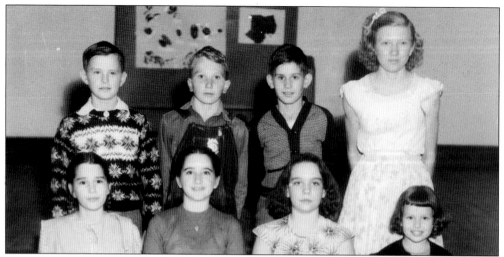

These children were fifth graders at Dunwoody School for the school year 1947–1948. Pictured from left to right are (first row) Pat Payne, Joan Barrow, Alice Porter, and Winnie Ruth Smarr; (second row) Harold Swancey, Ray Warbington, James Donaldson, and Dorothy Adams. (Courtesy of the Anderson family.)

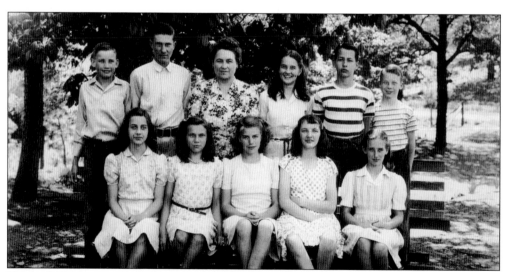

Elizabeth Davis poses with the seventh-grade class of Dunwoody School in 1948. The students pictured, left to right, include (first row) Esther Renfroe, unidentified, Viola Jackson, unidentified, and Joyce Eidson; (second row) Gilbert Stringer, unidentified, Elizabeth Davis, Anne Dempsey, Robert Ramsey, and Malcolm Davis. (Courtesy of the Anderson family.)

This graduation picture from Chamblee High School includes Carlton Renfroe, Esther Renfroe, and Jeff Porter. (Courtesy of the Renfroe family.)

The Chamblee High School class of 1950 gathered for this graduation photograph. Among the graduates seen here are Carlton Renfroe, Esther Renfroe, and Jeff Porter. In the years before Dunwoody received its own high school, after graduating from Dunwoody School, children went to high school in nearby Chamblee with students from Chamblee and Brookhaven. (Courtesy of the Renfroe family.)

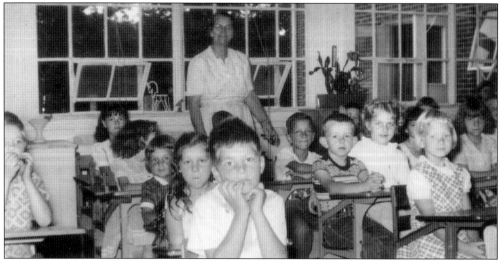

Nettie Austin was still teaching at Dunwoody School in the early 1950s. (Courtesy of the Austin family.)

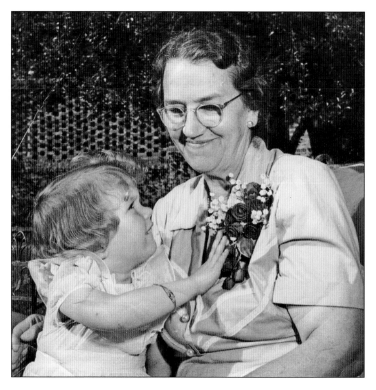

Nettie Southern Austin retired from teaching in 1949, although she still returned to Dunwoody School when needed. In this photograph, her granddaughter Ann is sitting in her lap. She received a silver tray at the retirement celebration and an article was written about the event by Edith Hills Coogler for the Atlanta newspaper. The headline read "Teacher of 46 Years Gets Surprise Fete of Lifetime." (Photograph by Pat Livingston, courtesy of the Austin family.)

Five

WARTIME IN DUNWOODY

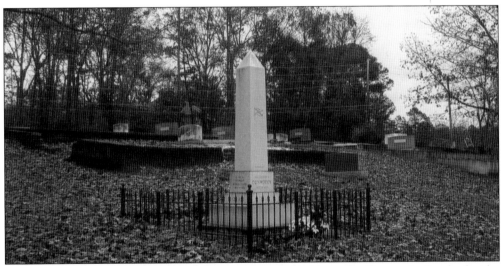

The namesake for Dunwoody, Maj. Charles Archibald Alexander Dunwody, fought for the Confederacy in the Civil War. He was born in Liberty County, Georgia, to John and Jane Dunwody. He married Ellen J. Rice and lived in Roswell before the war. He was first lieutenant of the Roswell Guards, Company H, 7th Regiment, but was never able to return to his post after being wounded in the hip at Manassas in 1861. He is credited with building the first bridge over the Chattahoochee River to Roswell after the Civil War (the previous bridge had been burned by Union troops). He also drew up a petition requesting a post office for the small farming community south of Roswell. It would be named in his honor (with an extra "o"). This monument to Dunwody's honor stands next to the Ebenezer Primitive Baptist Church. Dunwody is buried in the Roswell Historic Cemetery. (Photograph by Valerie Biggerstaff.)

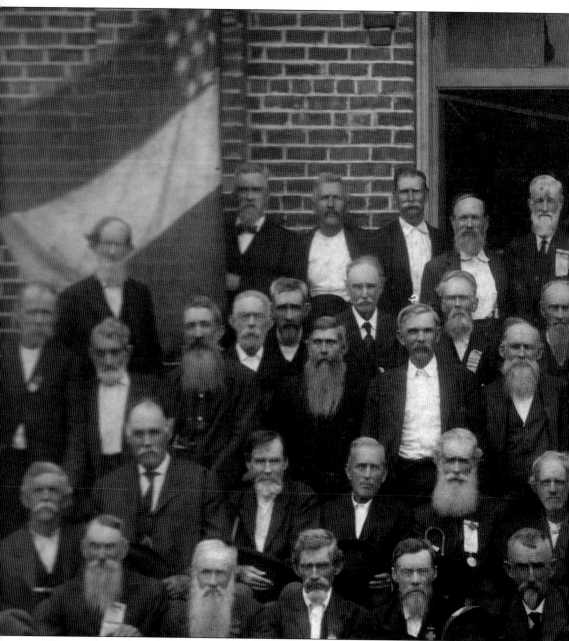

Dunwoody families who had men go off to fight with the Confederacy included Warnock, Adams, Dunwody, Austin, Carpenter, and Copeland, to name a few. Which family is represented in this Civil War reunion photograph is unclear. This photograph was among the family treasures of

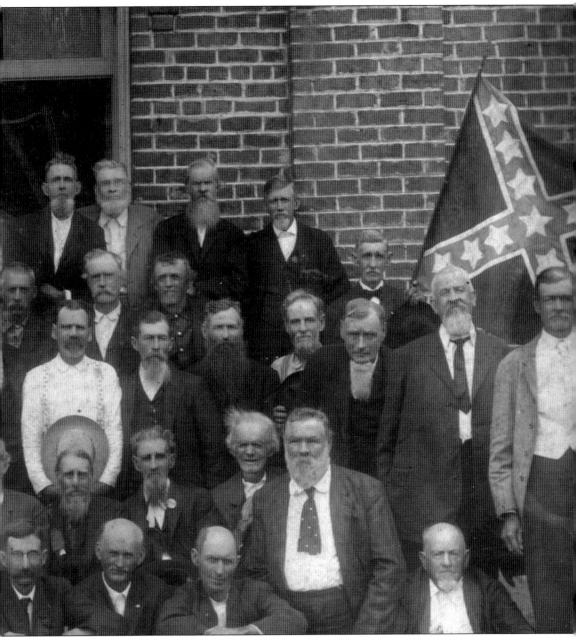

the Carpenter/Anderson family. The event pictured here was probably held in either Decatur or Atlanta. (Courtesy of the Anderson family.)

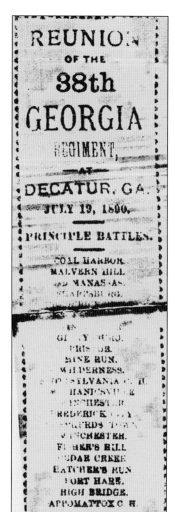

This document advertises a reunion of Confederate soldiers in Decatur, Georgia, on July 19, 1890. It belonged to William R. Warnock, who was wounded at Gettysburg. (Courtesy of the Ware family.)

This document describes William R. Warnock's injuries at Gettysburg. It was the form used to apply for disability due to injury. He was injured by gunshot on July 1, 1863—the first day of the three-day battle. (Courtesy of the Ware family.)

This Georgia historical marker is placed at the triangle where Chamblee Dunwoody Road and Nandina Lane meet. It marks where Gen. James B. McPherson and his Army of the Tennessee marched through Dunwoody on their way from Roswell to Decatur in July 1864. McPherson's army, the right wing of William T. Sherman's infamous March to the Sea, passed through and camped overnight on Nancy Creek near Ashford Dunwoody Road. They did not destroy any homes, but the Spruill, Carpenter, and Copeland families all tell in their histories of hiding items from the Union soldiers. A few days later, McPherson himself was killed outside Atlanta. (Photograph by Valerie Biggerstaff.)

PARTIAL VIEW OF CAMP.

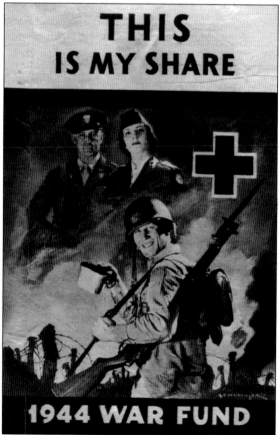

THIS IS MY SHARE

1944 WAR FUND

This postcard is of Camp Gordon, an army cantonment established in nearly Chamblee during World War I. Several young men from Dunwoody enlisted or were drafted, and many of those who remained behind worked on the construction of Camp Gordon. The Dunwoody community also did its part by inviting groups of soldiers from Camp Gordon to be entertained and fed a home-cooked meal. It is said the soldiers sometimes marched from Chamblee to Dunwoody and back. (Courtesy of Valerie Biggerstaff.)

This 1944 War Fund advertisement was part of Nettie Austin's school scrapbook. The students of Dunwoody School bought stamps and were proud to have 100-percent participation once their stamp books were full. (Courtesy of the Austin family.)

92

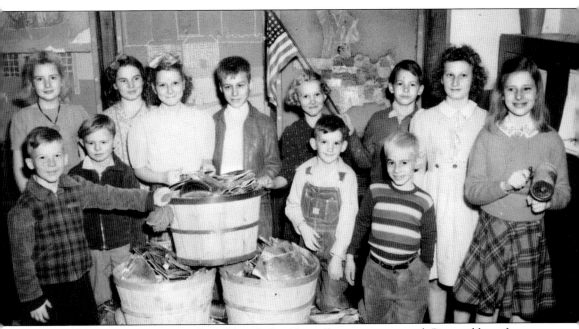

During World War II, Dunwoody children helped by collecting scrap metal. Pictured here from left to right are (first row) Malcolm Davis, Harold Swancey, J. D. Stringer, and James Renfroe; (second row) Margaret Ford, Miss Adams, unidentified, Carlton Renfroe, Margaret Henderson, Robert Ramsey, Bernice Adams, and Keller Henderson. (Courtesy of the Austin family.)

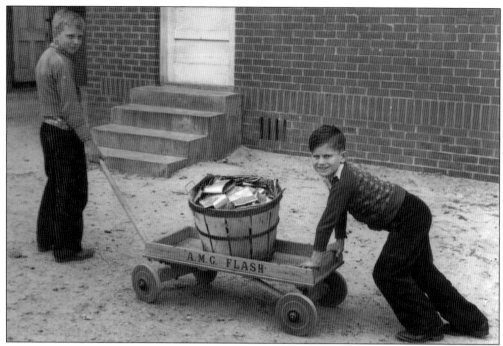

Clarence Warbington (left) and Jimmy Donaldson are shown collecting scrap metal and rubber for the cause during World War II. (Courtesy of the Austin family.)

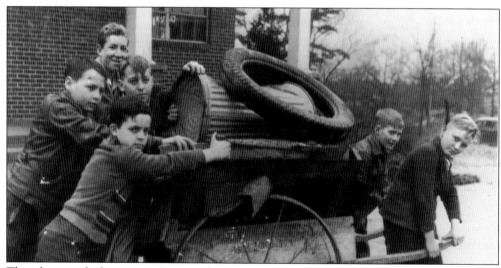

This photograph shows more Dunwoody youth doing their part during World War II. Pictured from left to right are Robert Dale Long, Melvin Warbington, Edwin Spruill, Archie Marchman, Travis Eidson, and Raymond Gunning. (Courtesy of the Austin family.)

Mary and Glenn Austin were newlyweds in Austin, Texas, in this photograph in the snow. Glenn was a flight instructor in the U.S. Army Air Corps at Bergstrom Air Force Base. (Courtesy of the Austin family.)

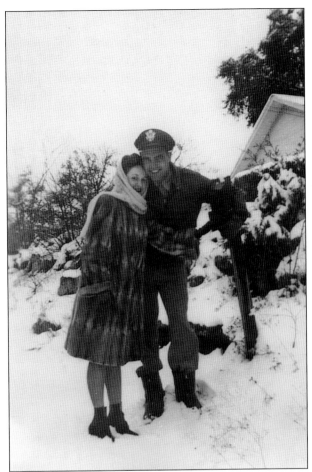

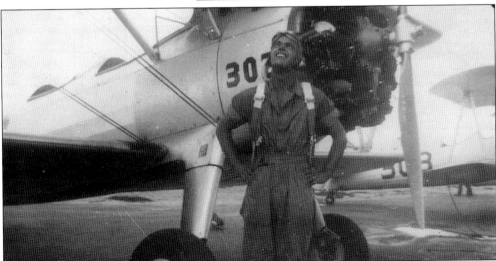

Glenn Austin would fly over his home and buzz his wife as a way of saying hello during the time they were stationed in Austin, Texas. He loved to do loops and rolls in his plane. (Courtesy of the Austin family.)

During World War II, children across the United States collected war stamps and filled books to give financial support to the war effort. In this 1943 image, Dunwoody School students proudly display their completed books. Nettie Southern Austin stands in the back of the classroom. In her scrapbook, she names the following children as officers of the "Victory Corps:" first lieutenant, Joel Morris; stamp chairman, Betty Warbington; tin can chairman, James Renfroe; M.P., Thomas Manning; scrap chairman, Juanita Marchman; librarian, Barbara Marchman. (Courtesy of the Anderson and Austin families.)

In this image, J. D. Stringer is on the far left of the back row, and Ken Anderson is second from left on the back row. This group of young men are being sworn in for service during the Korean War. (Courtesy of Ken Anderson.)

Six

CHURCHES

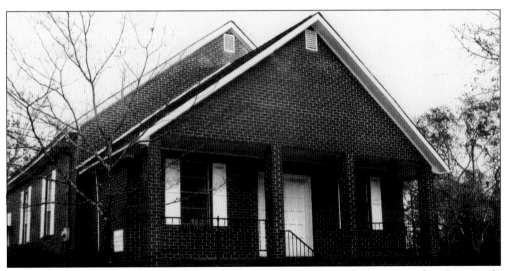

Ebenezer Primitive Baptist Church was first established in 1829, before any other Dunwoody church. It is located where Roberts Drive, Dunwoody Club Drive, and Spalding Drive meet. The Primitive Baptist church uses sacred harp music—the music of unaccompanied voices. The original church rolls included names still found locally today: Ball, Warnock, Holcombe, Martin, Jett, Dooley, Burdett, Abernathy, Roberts, Jordan, Adams, Dalrymple, and Carpenter. (Photograph by Valerie Biggerstaff.)

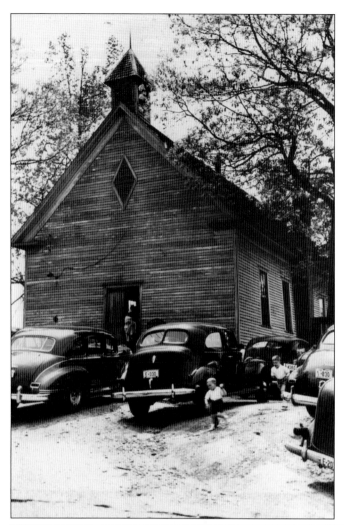

People of Dunwoody first began a Baptist church as early as 1853 in an old log cabin on Chamblee Dunwoody Road. The church pictured here was built in 1878. It was taken down in 1947. In front of the church is the Hudson automobile of visiting pastor L. B. Sauls. (Courtesy of the Anderson family.)

The New Hope Presbyterian Church was established in 1885. Charter members came from the following families: Weldon, Wing, Conway, Copeland, and McElroy. The church was gone by 1917, but the New Hope Cemetery remains in the same area. It is marked by one of the Dunwoody Preservation Trust's markers and is located on Chamblee Dunwoody Road. This photograph shows one of the old markers for the Copeland family. (Photograph by Valerie Biggerstaff.)

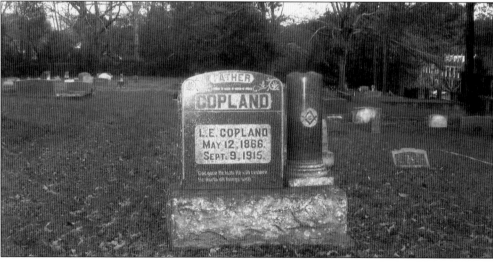

The first Dunwoody Methodist Church met at the Dunwoody School in 1899. In 1903, thirty-one charter members built the church pictured at right at a cost of $500. It was located across from where the present-day sanctuary sits on Mount Vernon Road. The church opened its doors on October 8, 1903, with Rev. Zedekiah Speer as pastor. (Courtesy of Dunwoody United Methodist Church.)

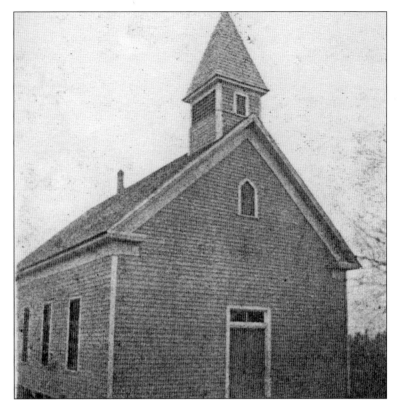

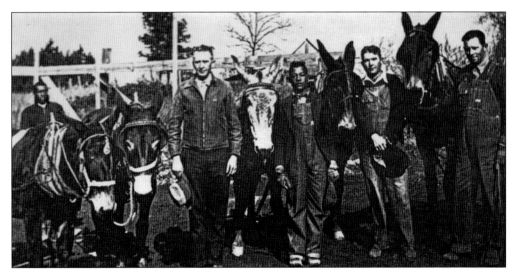

In 1935, Euill Spruill and a team of workers and mules gathered to excavate for the new Dunwoody Methodist Chapel on the north side of Mount Vernon Road. The chapel still stands today and is used every Sunday for children to gather in as part of their Sunday school hour. (Courtesy of the Dunwoody United Methodist Church.)

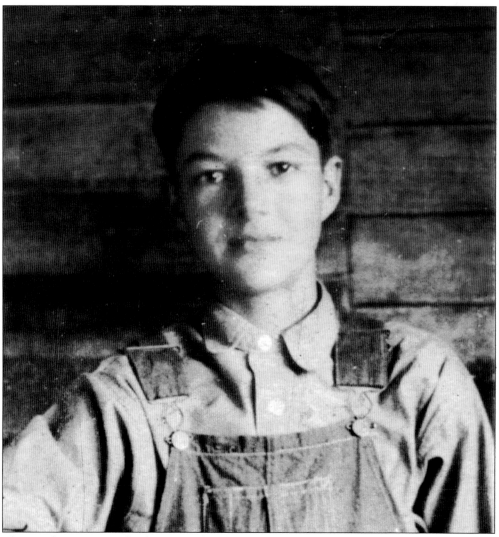

This is John Austin's school picture when he was about 10. He was the sexton for Dunwoody Methodist Church and was paid 25¢ a week for his work. His duties included opening up the sanctuary, sweeping the floors, setting out a glass of water for the preacher, and ringing the church bell 30 minutes before services began. Over the years, other Dunwoody children filled this same job. (Courtesy of the Austin family.)

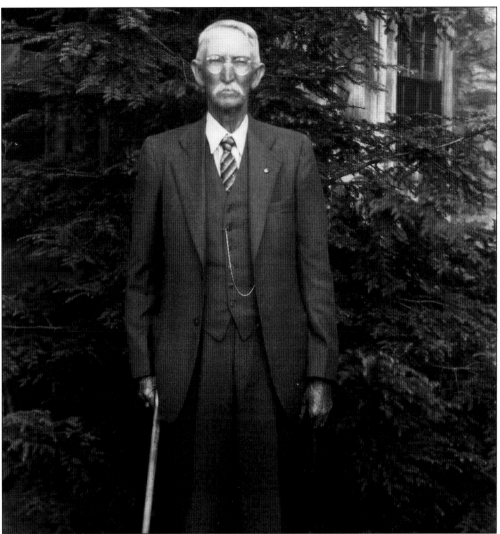

Calhoun Spruill walked 2 miles from his home to the Dunwoody Methodist Church every Sunday. Calhoun was one of the six sons of James Spruill and Mollie Jane Adams, Dunwoody pioneers. James and Mollie also had six daughters. Calhoun Spruill is visible in most of the group pictures of Dunwoody Methodist Church. This one was taken in the 1940s. (Courtesy of the Anderson family.)

The Dunwoody Methodist Church Sunday school classes gathered in front of the church about 1949 for this photograph. Among those pictured are Calhoun Spruill, the older gentleman on the left, and Stephen and Ethel Spruill, seated on the ground (she is wearing the dark hat). Also identified

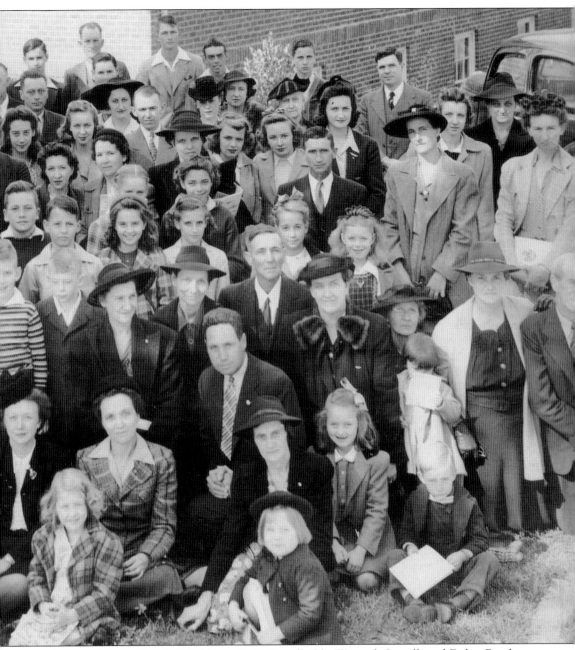

are Lamar Eidson, Charlie Blackburn, J. W. Spruill, Ola Womack Spruill, and Esther Renfroe. (Photograph by William Dunn Studios, courtesy of the Dunwoody United Methodist Church.)

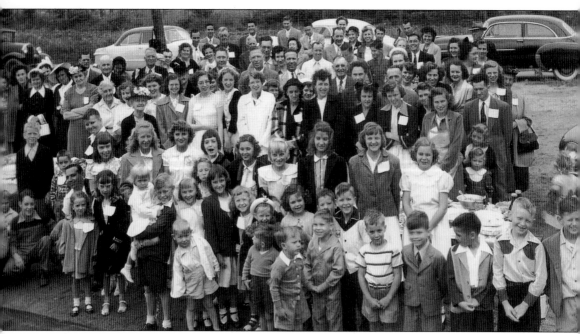

In the mid-1940s, Dunwoody residents gathered at the building site of the new Dunwoody Baptist Church building. Pictured in the center of this photograph is Alvilene Price, who had recently moved to Dunwoody. Her father worked at nearby Naval Air Station Atlanta in Chamblee and filled in the last of the railroad cut from the Roswell Railroad at the intersection of Chamblee Dunwoody Road and Mount Vernon Road. (Courtesy of the Anderson family.)

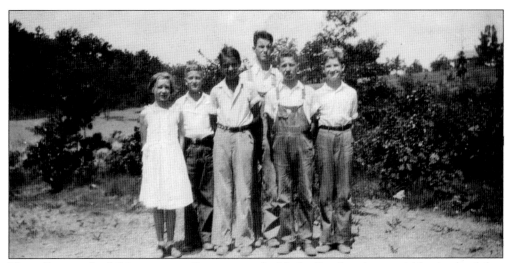

These Dunwoody children are standing next to the Methodist church on neighboring land that belonged to the Austin family. The third child from the left is Eddie Austin. (Courtesy of the Austin family.)

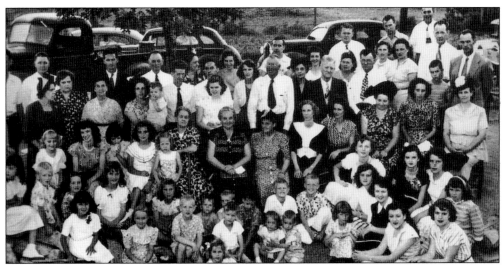

Members of the Martin, Carpenter, Spruill, Anderson, and Kirby families were on hand to celebrate the new Dunwoody Baptist Church building's construction. Following World War II, a fund was started for the structure, and $1,000 was collected. The church's new pastor, Rev. Walter Anderson, also served as construction supervisor. (Courtesy of the Anderson family.)

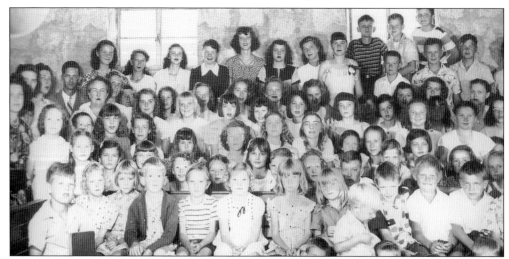

Dunwoody Baptist Church members gather for a photograph in the basement of their new church building. The church was on Chamblee Dunwoody Road at the time, next to the railroad section house. (Courtesy of the Anderson family.)

The sign outside of Dunwoody Methodist Church lets people know the Rev. Jack Bozeman is the preacher and that it is a friendly church. (Photograph by Rev. Jack Bozeman, courtesy of the Austin family.)

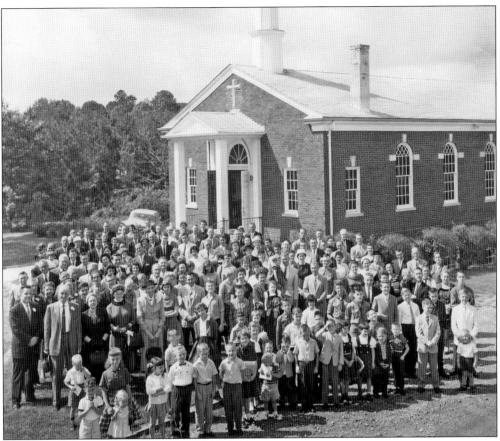

Sunday School attendees gathered for a photograph in front of the Dunwoody Methodist Chapel after renovations were completed in the mid-1950s. Stephen and Ethel Spruill are standing on the left side of the photograph—he is second from left on the front row, and she is third. Also shown in this picture, in no particular order, are Jim Warnes, Hattie Spruill, Calvin Eidson, Paula Warnes, Hugh Spruill, Beth Spruill, Ed Miles, John S. Austin, John S. Austin Jr., Jackie Bozeman, Mary Jordan, Lewis Miers, Jim Funsten, Kathleen Miers, Rev. Jack Bozeman, and Elizabeth Davis. Among the children in front are Joanie Warnes, Chris Austin, Bill Pinchback, Jimmy Warnes, Jimmy Funsten, Suzanne Austin, Molly Miers, Roger Miers, Glenn Austin Jr., Sandra Pinchback, and Michael Austin. (Photograph by William Dunn Studios, courtesy of the Austin family.)

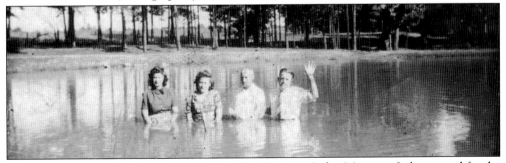

Walter L. Anderson (on the right) is baptized at Manning Lake. Manning Lake, named for the family of the same name, is now part of the Meadowlake subdivision. Walter Anderson was pastor of the Dunwoody Baptist Church during the 1940s. (Courtesy of the Anderson family.)

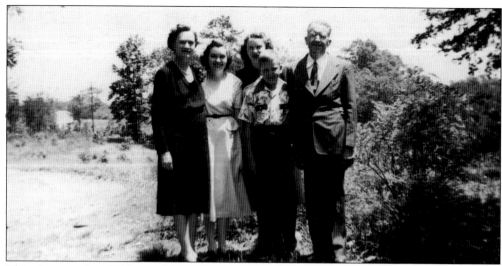

This photograph of Walter and Lucy Carpenter Anderson and their children was taken in the late 1940s. Pictured from left to right are Lucy Carpenter Anderson, Carolyn Anderson, Jane Anderson, Ken Anderson, and Walter Anderson. (Courtesy of the Anderson family.)

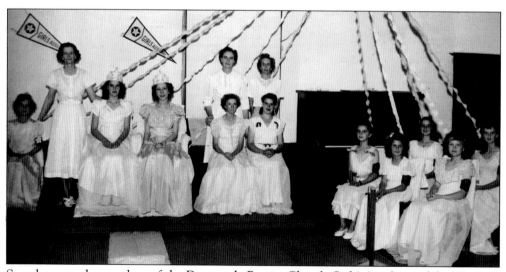

Seen here are the members of the Dunwoody Baptist Church Girls' Auxiliary of the Women's Missions Union. From left to right are Joan Jameson, unidentified, Martha Jackson, Mary Price, Alvilene Price, Lucy Anderson, Viola Jackson, Mary Sue Jamison, Jean Kirby, Jerry Burrell, Renae Adams, Joan Barrow, and Corrine Borne. (Courtesy of the Anderson family.)

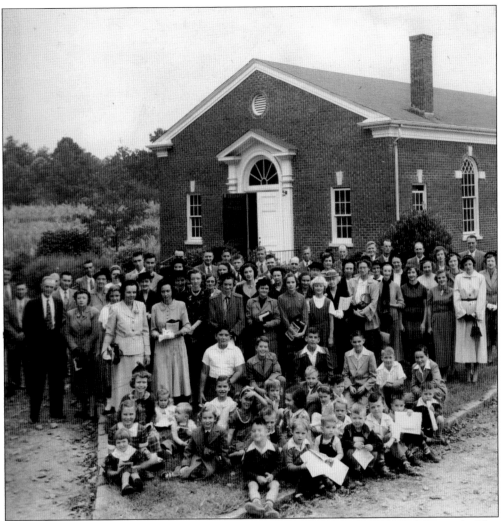

Dunwoody Methodist Sunday school attendees gather outside the chapel for a photograph. This one was taken around 1950 by the William Dunn Studios. Standing at far left are Stephen Spruill and Ethel Spruill. Also pictured, in no particular order, are John Austin Sr., Edith Bullard, Nettie Southern Austin, Glenn Austin Jr., John Austin Jr., Mrs. Wilson, Hugh Spruill, and Calvin Eidson. (Courtesy of the Austin family.)

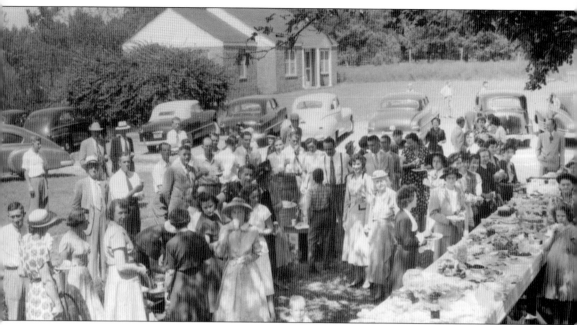

Soon after a new parsonage was completed for the Dunwoody Methodist Church, the congregation held a dinner on the grounds to celebrate. Among those attending were (in no specific order) Ann and Glenn Austin, Nettie Austin, Eddie Austin, Elizabeth Davis, Hattie Spruill, Steve Spruill, Claude Spruill, Gene Donaldson, Nancy Miles, Ricky Miles, Peggy Miles, Mrs. Psalmonds, Charlie Blackburn, Margaret Wilson, Rev. J. C. Moore, Dr. Floyd, Marie Marchman, Charlie Marchman, Calvin Eidson, Harvey Womack, and Clarice Green. (Courtesy of Dunwoody United Methodist Church.)

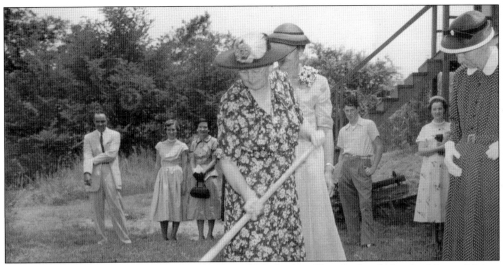

In 1954, the members of the Dunwoody United Methodist Church decided to build an addition to the sanctuary. Lemma Henry Spruill had the honor of starting off with the first shovel. Also pictured are Nettie Southern Austin and Hattie Hardin Spruill. George R. Vinson was the architect for the addition. Rev. Bill Echols was the pastor at the time. (Courtesy of Dunwoody United Methodist Church.)

This photograph shows Dunwoody Methodist Church in 1955, after the additions had been completed. New space was added in back, seen on the left side of the chapel. A cover was also added over the front door. (Courtesy of Dunwoody United Methodist Church.)

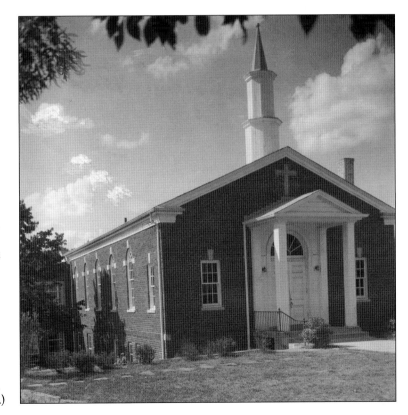

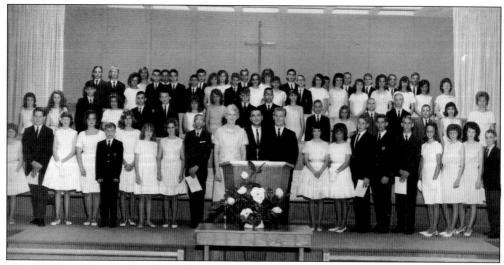

This 1960s graduation of students from Dunwoody School took place at the Dunwoody Baptist Church. (Courtesy of the Anderson family.)

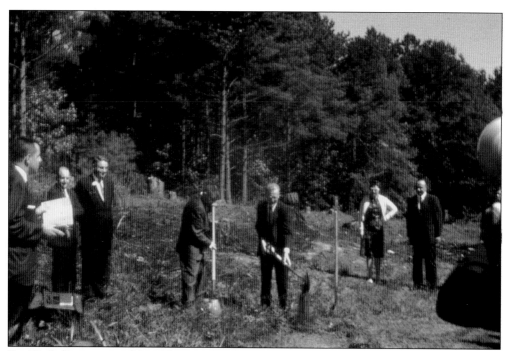

Rev. Jack Bozeman and Jim Warnes are shown in this 1960s image as the congregation of the Dunwoody Methodist Church breaks ground for its new fellowship hall. (Courtesy of the Austin family.)

In 1969, a new parsonage was constructed for Dunwoody's Methodist church. Pictured on the parsonage's front porch are, from left to right, Ann Van Pelt, Weldon Van Pelt, Rev. William H. Gardner, and Katherine Gardner. (Courtesy of Dunwoody United Methodist Church.)

Rev. E. Owen Kellum and Rev. Ben Rosenkranz (far right) are pictured at a 1971 ground-breaking ceremony for a new sanctuary to meet the needs of the United Methodists' growing congregation. (Courtesy of the Dunwoody United Methodist Church.)

Members of the chancel choir of Dunwoody United Methodist Church in 1970 included Mary Austin, Evelyn Coone, Ruth Crozier, Harriett Hardy, Marian Kagebein, Olive Kellum, Marilyn McLeod, Jane Mashburn, Virginia Smock, Mary Lou Wagemann, Beverly Brodier, Barbara Buckner, Betty Heflin, Mary Jean Ligon, Maggie Pardue, Joan Springs, Marjorie Williams, Jack Brosher, Larry Gunter, Don Vann, Glenn Austin, Jack Dempsey, George Giesel, Wallace McLeod, Dave Rife, Dave Springs, director Barbara Purkerson, and organist Graham Purkerson. (Courtesy of the Dunwoody United Methodist Church.)

These children attended Sunday school at Dunwoody Methodist Church in 1977. Pictured from left to right are (first row) Sam Kemp, unidentified, Danny Bartlett, David Brown, two unidentified, Dean Burge, and Kent ?; (second row) unidentified, Jenne De Chart, unidentified, Curtis Gill, Leslie Cooper, Stacey Oxley, two unidentified, Ola Jordan, Catherine Younts, and Amy Mauldin. (Courtesy of Dunwoody United Methodist Church.)

The bell displayed on the front lawn of Dunwoody United Methodist Church was given to the church by Ike Roberts, conductor of the Roswell Railroad for all of the 40 years it was operational. Roberts also once owned a wool mill in Dunwoody. When town resident John Austin was 11 years old, he rang the bell a half-hour before church started each Sunday. (Photograph by Valerie Biggerstaff.)

Seven

BUSINESS AND COMMUNITY

$1.00

DeKALB COUNTY, GA., *October* 190__

R*eceived of* F. O. Carpenter

of 524 *District, G. M.,* 100 *Dollars.*

Commutation Road Tax for fall of 190 2

No. Days Worked IIII½ Mule M ¾

W. A. Gardner

In 1902, Dunwoody residents could use their own labor to offset taxes. This receipt for commutation of road tax for district 524 shows that F. O. Carpenter did 4.5 days of work, and his mule did 2.75 days of work. For this work, Carpenter was credited $100. The receipt is signed by W. A. Gardner, overseer. (Courtesy of the Anderson family.)

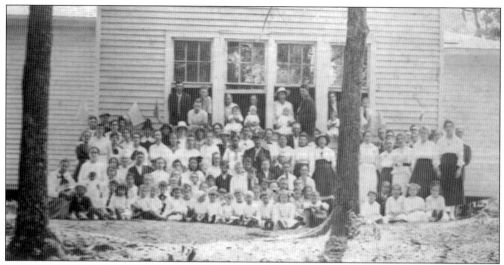

Seen here in the 1920s, Dunwoody residents gather to celebrate the Fourth of July. Those who have been identified in this photograph include (in no specific order) Nettie Austin, Glenn Austin Jr., Bence Spruill, Mr. and Mrs. Blackwell, Mr. and Mrs. Calhoun Spruill, Hattie Spruill, Florence Warnock, Mrs. W. L. Anderson, Carolyn Anderson, Gladys Austin, John Austin, and Sarah Austin. Children in the first row include Early, Onnie, and Lois Spruill. (Courtesy of the Anderson family.)

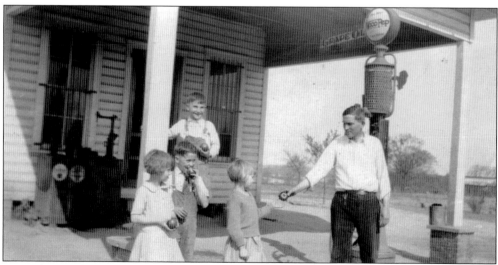

Lon Eidson is shown around 1930 outside his Dunwoody store and gasoline station. The Eidson home, which still stands today, is near where the store is located on Chamblee Dunwoody Road. The gasoline sign is for Woco Pep, which later became Pure Oil. On the front porch of the store is a kerosene or oil bin where customers filled containers with kerosene for lamps or oil for their automobiles. (Courtesy of the Austin family.)

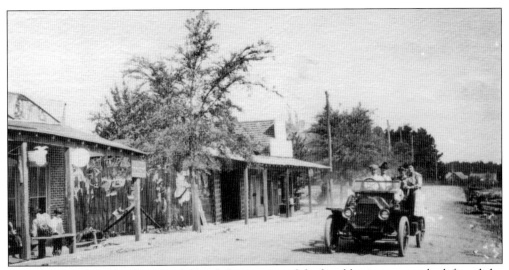

This view of Chamblee Dunwoody Road shows some of the local businesses on the left and the remains of the railroad track on the right. On the left seems to be a livery stable and the Nash home and store. Farther down the road was Dr. Pucket's home and office. There were two doctors in Dunwoody in the 1920s: Dr. Pucket and Dr. Duke. (Courtesy of Gewin Flowers.)

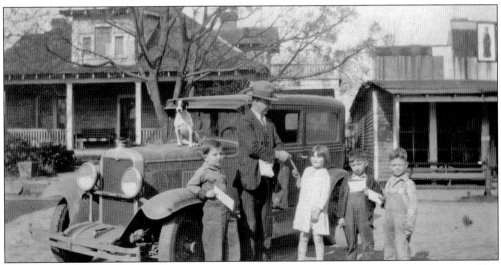

The store in this photograph belonged to the Nash family. Mrs. Nash operated the post office that was across the road; it is not known who the gentleman is who is distributing mail to the children. Court was held once a month in the upper level of the store by Glenn G. Austin, justice of the peace. (Courtesy of the Austin family.)

The Dunwoody crossroads at Mount Vernon Road and Chamblee Dunwoody Road looked quite different in 1958. To the left is Thompson's Grocery, which also housed the local post office. The building was once the Dunwoody train depot and was moved to this location by rolling the building on logs up Chamblee Dunwoody Road. (Courtesy of the Anderson family.)

This snowy view of Dunwoody was taken in the 1960s. The picture was taken along Mount Vernon Road near the Chamblee Dunwoody intersection and shows how little development there was at that time. (Courtesy of the Austin family.)

These photographs are of Camp Ajecomce, a camp that was located where the Marcus Jewish Community Center is now. The original camp, shown here in 1963, was fairly small compared to the large campus and varied activities available at the Marcus Jewish Community Center today. The land where the complex sits was once the home of the Porter family. (Courtesy of Georgia State University.)

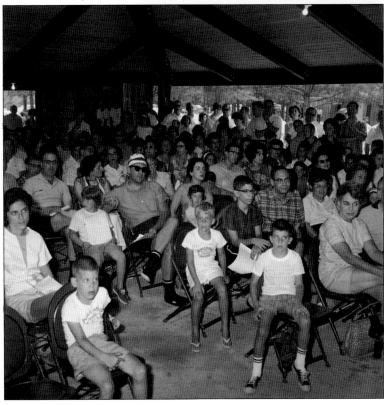

This country store and gasoline station, photographed in the 1970s, shows how undeveloped the area surrounding Dunwoody remained in those years. The store sat at the corner of Jett Ferry Road and Mount Vernon Road. Joe Kelly built and ran the store first, followed by Georgia Carpenter Anderson and Offalee Anderson, then Mr. Sparks and Mr. Wilson. (Courtesy of the Anderson family.)

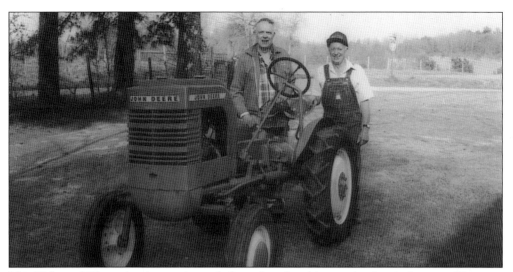

Max Kirby and Glenn Austin are pictured after a day of working on the Austins' tractor. (Courtesy of the Austin family.)

In 1996, the Summer Olympic games came to Atlanta. The torch passed through Dunwoody, and residents lined the streets awaiting its arrival on a hot July day. (Photograph by Valerie Biggerstaff.)

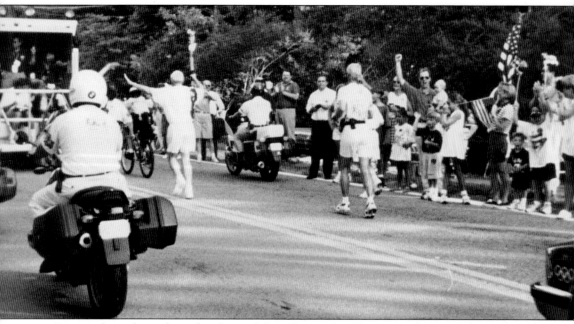

Dunwoody residents cheered and waved their flags as the Olympic torch passed along Chamblee Dunwoody Road on its way to the center of Dunwoody, eventually passing by the Dunwoody Farmhouse. (Photograph by Valerie Biggerstaff.)

Ken Anderson and Alvilene Price Anderson attended a Dunwoody School reunion in 2008 along with several other graduates. Many brought photographs and mementos (such as report cards) to share with others. (Photograph by Valerie Biggerstaff.)

Seen here from left to right, Jeff Porter, Carlton Renfroe, and Margaret Henderson Jenkins planned the reunion of Dunwoody classmates. (Photograph by Valerie Biggerstaff.)

Eddie Austin and Frances Austin attended the reunion; he was the oldest graduate there. He brought the bell that his mother, Nettie Southern Austin, had used when she was a teacher at the school. (Photograph by Valerie Biggerstaff.)

BIBLIOGRAPHY

Austin, James Waddy and Josephine Manning Austin Knight. *The Austin and Allied Families*. 2nd Edition. Atlanta, GA: Self-published, 1972.

Davis, Elizabeth L. and Ethel W. Spruill. *The Story of Dunwoody: Its Heritage and Horizons 1821–1975*. Dunwoody, GA: Williams Printing Company, 1975.

Davis, Elizabeth L., Ethel W. Spruill, Joyce Amacher, and Lynne Byrd. *The Story of Dunwoody, 1821–2001*. Dunwoody, GA: Wolfe Publishing Company, 2002.

Perkins, Jim and Bill Drury. *The Writings of Jim Perkins: Dunwoody Historian*. Dunwoody, GA: Self-published, 2005.

www.arcadiapublishing.com

MAP SEARCH

Discover books about the town where you grew up, the cities where your friends and families live, the town where your parents met, or even that retirement spot you've been dreaming about. Our Web site provides history lovers with exclusive deals, advanced notification about new titles, e-mail alerts of author events, and much more.

Find Your Place in History.